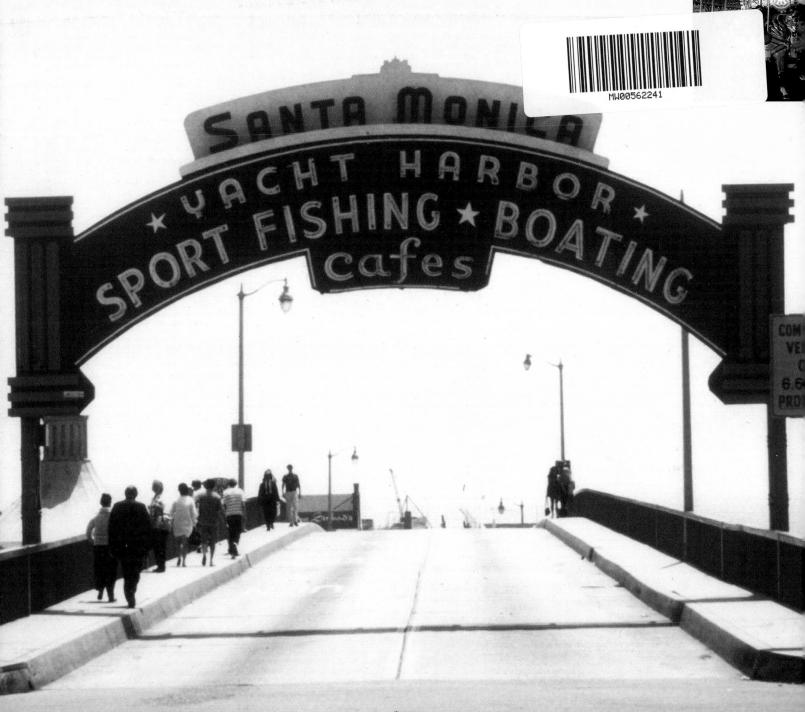

*

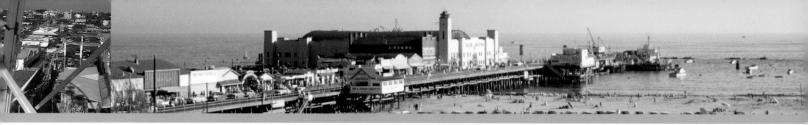

Santa Monica Pier

A Century On The Last Great Pleasure Pier by James Harris

Copyright © 2009 by The Santa Monica Pier Restoration Corporation

10987654321

ISBN-13 978-1-883318-82-6 / ISBN-10 1-883318-82-3

All rights reserved. No part of this book may be reproduced or transmitted in any form or by any means, electronic or mechanical, including photocopying, recording, or by an information storage and retrieval system, without express written permission from the publisher.

Names and trademarks of products are the property of their registered owners.

Design by Amy Inouye, www.futurestudio.com

Library of Congress Cataloging-in-Publication Data

Harris, James, 1965-

Santa Monica Pier : a century on the last great pleasure pier / by James Harris ; foreword by Robert Redford. p. cm.

Summary: "The Santa Monica Pier has summoned the imagination of the world for a century. Vintage images, colorful artwork, fascinating history and treasured lore invites anyone who has ever enjoyed the Pier to walk through time on it, live its culture, struggle through its lean years, fight for its very survival and see it become a National Historic Landmark"—Provided by publisher.

ISBN 978-1-883318-82-6 (trade paper : alk. paper)

- 1. Santa Monica Pier (Santa Monica, Calif.)—History. 2. Santa Monica (Calif.)—Social life and customs.
- 3. Santa Monica (Calif.)-History. 4. Recreation-California-Santa Monica. I. Title.

F869.S51H37 2009 979.4'93—dc22

2008049686

The author extends his deepest gratitude to those who have contributed images to this book. Without their generous contributions, this book would be far less interesting. All images are from the Santa Monica Pier Restoration Corporation Collection except those listed below, which are reproduced by permission:

Academy of Motion Picture Arts and Science 68 (bottom), 69 (left), 70 (bottom), 71, 106 (bottom); Courtesy of Larry Barber 115; Cindy Bendat 9, 37 (bottom right), 59 (bottom left), 80 (bottom), 81 (top), 82 (top), 82 (bottom), 84-85, 92, 93; Campbell & Campbell 20 (left, middle); Cirque du Soleil 37 (top right); Colleen Creedon 96; Kris Dahlin 115 (right); Courtesy of Patricia DeSimone 110; DLT Entertainment Ltd. [threescompany.com] 68 (top); Courtesy of the Jay Fiondella Family 57 (center); Steve Galloway 7, 8, 9; Helen Garber 36, 58 (top right); Courtesy of Ken Genser 10-11, 106 (top); Courtesy of Roger Genser 8, 26 (bottom), 30-31, 38, 43, 59 (center), 60-61, 100 (bottom right), 109; Courtesy of Jim Hernage 2-3, 87, 88 (top), 89 (top center), 89 (center left); Amy Inouye 20 (right), 37 (bottom left, inset), 57 (bottom right); Courtesy of Richard J. Kaplan 112 (left and bottom); King Features Syndicate 28; KTLA-TV 106 (bottom); Los Angeles Public Library 41, 49, 98, 104 (top), 112 (top); Los Angeles Times 47; Courtesy of Ernest Marquez 17 (right top, middle and bottom), 24-25, 32, 33, 37 (top left), 39, 48, 57 (top), 101, 102; Karen Maze 126 (top right), 127 (top); Michael C. McMillen 4, 5; Manny Mendelson 89 (center right); Stuart Rapaport 17 (left), 90; Courtesy of Ed Ries 91; Santa Monica Harbor Patrol 53 (top right), 53 (bottom), 111; Santa Monica Historical Society Museum 13, 14, 15, 23, 26 (top), 27 (top), 34, 59 (bottom right), 62, 64 (bottom), 70 (top), 105, 118, 119; Santa Monica Public Library 4, 6, 7, 12, 51, 54, 56, 57, 78 (bottom), 83, 86, 113 (left), 117 (top center), 123, 123 (inset); Santa Monica Evening Outlook Archives 35, 40, 55, 104 (bottom right), 109 (top), 121 (top) right); Elizabeth R. Sedat Collection 22 (top); Paul Silhavy 72, 73 (top); UCLA Department of Geography, Benjamin and Gladys Thomas Air Photo Archives, Spence Collection 19; UCLA Charles E. Young Research Library Department of Special Collections 18, 46, 47 (center), 50, 69 (right); Universal Pictures Corporation 8, 69 (right), 70, 71; Courtesy of Arthur Verge 52, 53 (top left), 103; John Volaski 89 (top left); Warren Aerial Photography 76; Rachel Waugh 81 (bottom); Courtesy of the Jane Whiting Family 1, 29, 44, 45, 57 (top left), 94 (bottom); Doug Wright Collection 75, 88 (bottom), 89 (top right), 89 (center), 89 (bottom); Tom Zimmerman 94 (top), 108, 117 (bottom right), 128; Courtesy of Harold Zinkin Family, 59 (top left).

Published by Angel City Press 2118 Wilshire Blvd. #880 Santa Monica, California 90403 U.S.A. +1.310.395.9982 www.angelcitypress.com

Dedication

This book is dedicated to everyone who has ever loved the Santa Monica Pier.

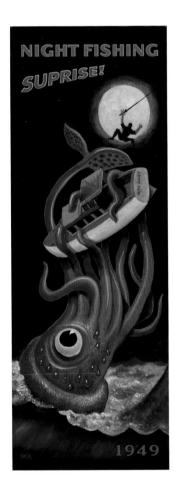

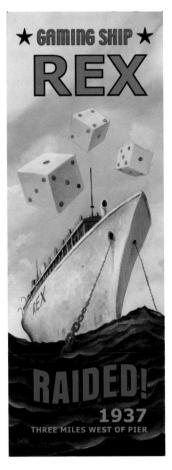

Banners above, opposite, and pages 7, 8 and 9: On July 1, 2004, the City of Santa Monica's Cultural Affairs Division and Santa Monica Arts Commission unveiled a series of twenty-nine banners created by artists Michael C. McMillen and Steve Galloway to celebrate the pier's history and lore. Hung on the light posts along the length of the Municipal Pier, the compelling banners left it to observers to determine which are based in fact and which are mythical. McMillen's work is featured above and opposite; Galloway designed the banners on pages 7, 8, 9 and the back cover.

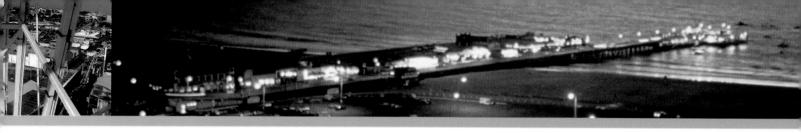

Acknowledgments

any people have made important contributions to this book. Their memories and insight helped me to bring forth the true personality of the Pier. I wish to thank each of them as listed below for sharing their valuable time and priceless information; some for graciously sharing their images as well. To anyone whose name I may have inadvertently overlooked, I offer my most sincere apologies, but my assurance that their great contribution is not forgotten.

Joan Baez, Jose Bacallao, Bob Barber, Larry Barber, Russell Barnard, Charles Béraud, Pete Breceda, Diana and Carol Cherman, Don Camacho, Stan Chambers, Fred Dahlinger, Patricia DeSimone, Tim Dillenbeck, Denise Fast, Drew Feldman, the late Jay "Chez Jay" Fiondella, Barry A. Fisher, Susan C. Fletcher, Dennis Friedman, Keith Goldsmith, Marlene and Joanie Gordon, Tony Haig, Tom Hayden, Jim Hernage, Rick Howard, Herb Katz, Jay Kennedy, Katharine King, Jeff Klocke, Mike Lopez, Brian and Eleanor Morgan, Bob Morris, Maynard and Sheila Ostrow, David Pann, Randi Parent, Stuart Rapeport, William Rivera, Adriana Roth, Paul Sand, "Captain Ron" Schur, J.D. Simpson, Dace Taub, Jamie Trinkkeller, John "Yosh" and Chris Volaski, Jane, Linda and Patti Whiting, Barbara Williams, and all of the crew at Santa Monica Harbor Patrol.

Ed Ries and Arthur Verge, fellow authors who share my love for the Pier, have been extraordinarily supportive of this project, and special thanks are due to each. Author Harry Medved repeatedly suggested that I write this book, and I can't thank him enough for that. Jeffrey Stanton should also be acknowledged, for his book *Santa Monica Pier: 1875–1990* piqued my interest in the Pier's life story almost twenty years ago, and I've been obsessed ever since. I am especially grateful to Robert Redford for his thoughtful and thought-provoking Foreword.

Many hours were spent at Santa Monica Public Library reviewing what seemed like miles of archived Santa Monica Evening Outlook material on microfilm. Likewise, the Abbott Kinney Memorial Branch of the Los Angeles Public Library allowed me plentiful access to the Los Angeles Times archives. The staffs at both libraries were extraordinarily helpful.

Nancy Greenstein and Barbara Williams have been kind enough to review particular sections of the manuscript; noted Santa Monica historian Ernest Marquez, author of *Santa Monica Beach*, has inspected the entire book, as have Cindy Bendat, Colleen Creedon, Ben Franz-Knight and Sandra Pettit. All have contributed important corrections, comments and advice and none is responsible for any errors of fact or emphasis that may remain.

Special thanks go to the Santa Monica Pier Restoration Corporation, my employers, for giving me the opportunity to dedicate valuable company time to the research and writing of this book. The support and encouragement of both Board and staff have been truly inspiring.

Heartfelt thanks also goes to Theresa Accomazzo, Paddy Calistro, Scott McAuley and Amy Inouye of Angel City Press, whose editorial and artistic experience made this book even better than I could have imagined.

Finally, I wish to thank my wife Amanda Harris, step-daughter Hayley McGlynn and new daughter Stella for their understanding and patience with the numerous hours that they lost me to, as Amanda calls the Pier, my "other wife." Without their support this book may never have been written.

—James Harris

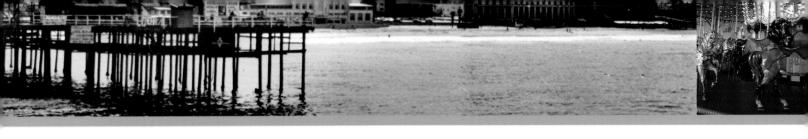

Contents

Part 1. The Early Years
The West Coast's First Concrete Pier
Birth of the Amusement Pier
Bitti of the finadement for
Part 2 · Expansion and Contention
A Succession of Suitors
Launching a Yacht Harbor
The Newcomb Years
The West End
Keeping the Harbor Afloat
Part 3 · The Last Great Pleasure Pier
Save the Pier!
The Storms of 198372
Restoration
Part 4. Pier Icons
The Best Fishing in the Bay
The Carousel & Hippodrome
The La Monica Ballroom
Past Businesses on the Pier
The Pier's Memory Lane
Rides & Amusements

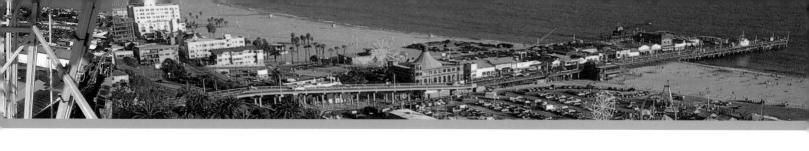

Foreword

by Robert Redford

s I reflect upon Santa Monica Pier—a place of significant personal experience and great history, I am struck by the importance it plays on an individual level, in the community and as an internationally recognized

symbol of California. When I was a child, it was the wild frontier—the escape from the city to the east. It was a place of vision and creativity where I spent hours enjoying the rides and games, marveling at the skill of the fishermen and enjoying the ocean air, wideopen skies and endless horizon.

My folks and I lived in a lower-working-class neighborhood in Santa Monica, and there wasn't much to do except go to the ocean, walk the boardwalk, build castles in the sand and imagine magical things.

It was Santa Monica Pier that revealed to me I was four years old. I was walking with my grandmother along the boardwalk when another kid accosted me. He asked me how old I was and I must have said four, because he laughed and said, "Well, I'm five. I'm

> older than you." I remember his hat (a sailor hat), behind him the merrygo-round on the Pier circling and circling and the uneven sound of the calliope's music, fresh and tantalizing. That was one of my first memories of childhood, and it burned its image in my mind forever.

> Since 1909 the Pier has remained a constant of the Southern California coastline and has weathered many storms, enduring lean economic times and the power of Mother Nature. L.A. has served up many of its historic landmarks to the ugly ravages of development and progress. As such, in 1973, Santa Monica Pier was slated for demolition, set to follow Venice Pier and Pacific Ocean Park Pier into memory and lore.

> The filming of The Sting coincided with this pivotal moment

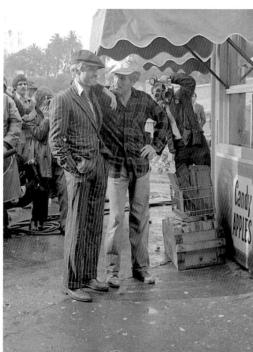

Santa Monica Pier

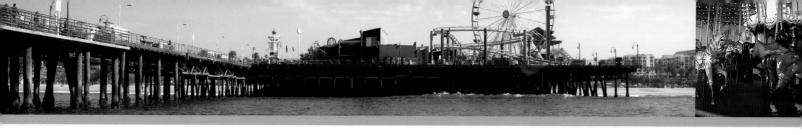

in Pier history. As we used the inherent historic qualities of the Carousel to recreate 1930s Chicago for the movie, we became acutely aware of the importance of the effort to preserve the Pier's actual history. This film location

had also been a scene of joy in my own life years earlier. The real and "reel" worlds joined together in that time and space . . . at least for me (and that is just one story of so many that have taken place for each and every person who has visited the Pier over the last hundred years).

It was an important experience for me, and a pivotal moment for the fate of the Pier as well. I was impressed by the power of community activism that had developed, and it was with pride that I joined so many others in signing the petition to save the structure and its many facets.

The knowledge that our creative filmmaking efforts on the Pier played a role in the preservation of the physical historic landmark serves as a lasting testament to the power of the Pier as a place that marries lore, fact, fiction, dreams, reality and the power of a grassroots movement to preserve this treasure for all to enjoy. Walking on the Pier, one can simultaneously experience the fantastic reality of the wind, waves, sand and creaking wooden decks, and travel back in time to the simple pleasures of the Carousel and its timeless amusement.

I have had the great fortune of viewing the Pier through several sets of eyes—those of a child, an adult, a professional, and an old friend. As you peruse the pages of this book, I hope that you too enjoy the journey of cherished youth, triumph over adversity and challenge, and growth from modest beginnings to becoming an icon. The Pier reminds me of our youth, our innocence. Such places are hard to find.

Welcome to Santa Monica Pier, A Century on the Last Great Pleasure Pier.

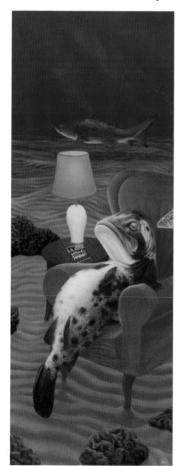

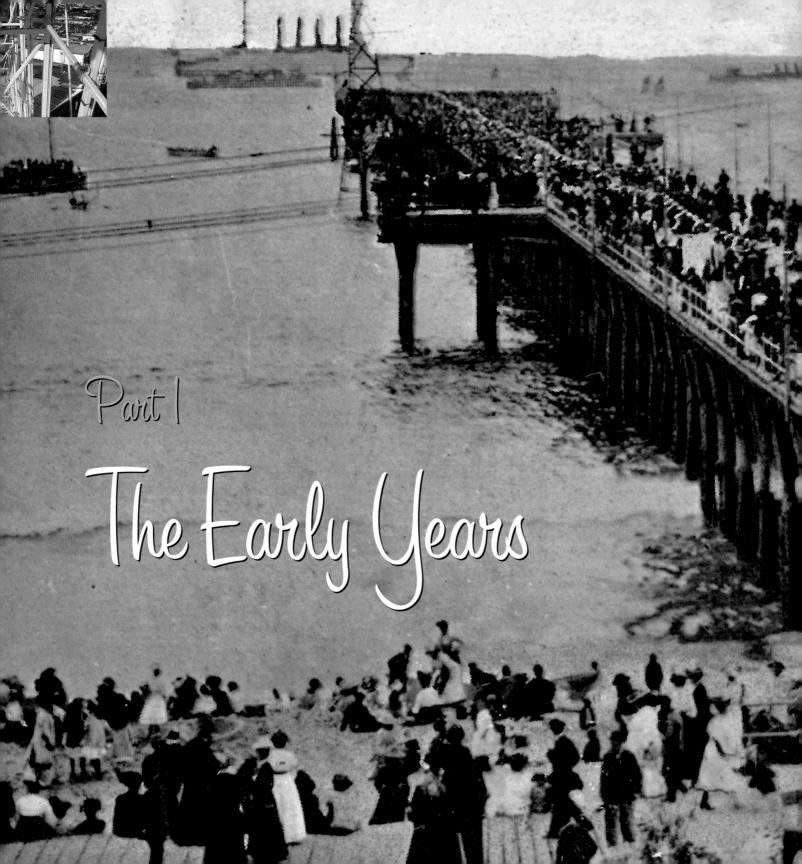

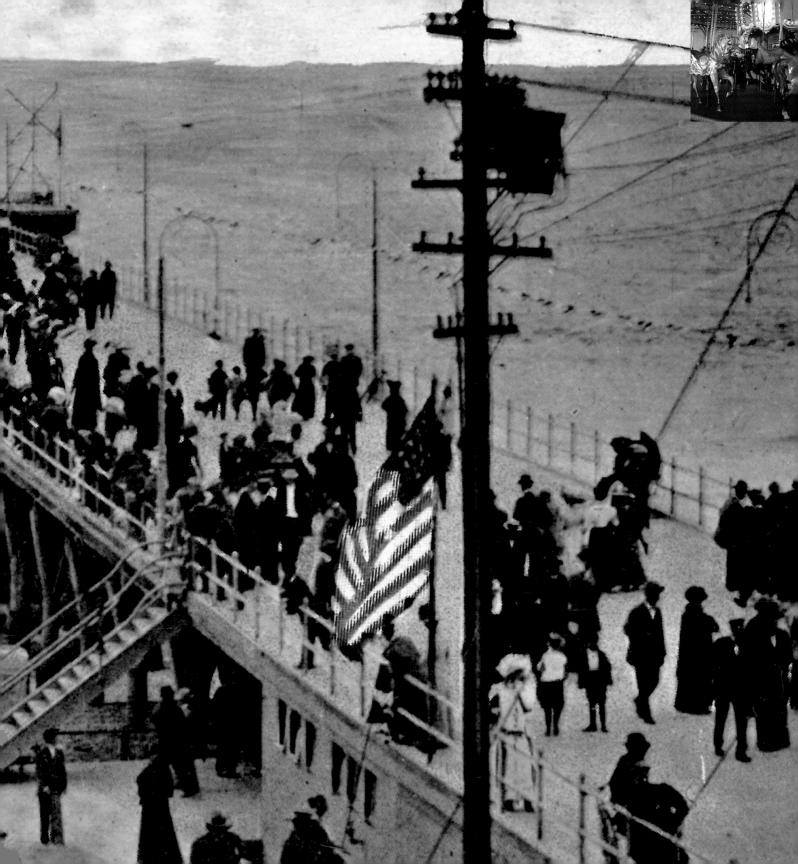

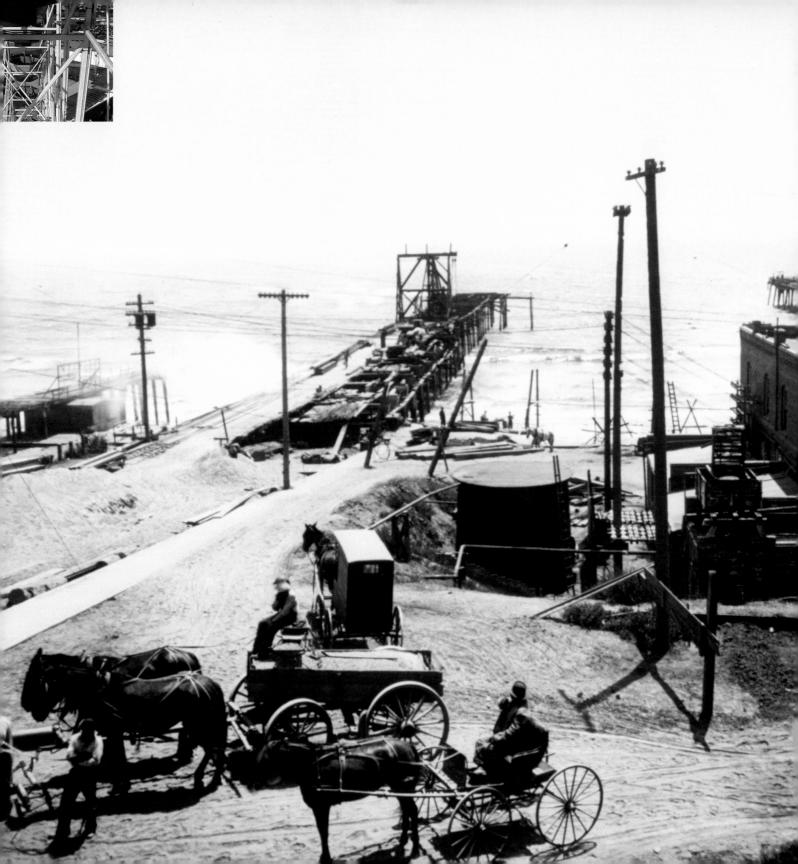

The West Coast's First Concrete Pier

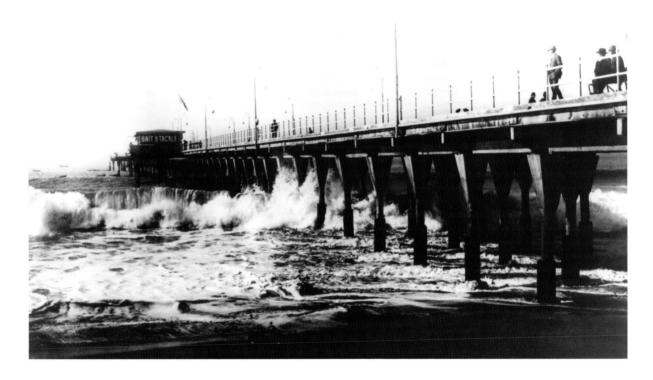

rgan music emanates from the Carousel Building while, inside, hand-carved wooden horses race in an endless circle. Laughter resonates through the air as wooden deck boards creak beneath people's footsteps, the rhythmic roar of the waves never far away. A cool breeze carries the aroma of hamburgers, broiled fish, and fresh-popped popcorn, all mixing splendidly with the salt air. A roller coaster thunders along its track as passengers scream with delight. Seagulls chatter above erratic rows of fishing poles propped up along the blue railing, joining in the hope for a successful day's catch. Dancing lights invite passersby to board the Ferris wheel . . . Who can

After several wooden piers succumbed to violent storms or to deterioration, the City of Santa Monica chose to build its Municipal Pier using concrete. It was the first concrete pier built on the West Coast of the United States.

Opposite: Construction on the Municipal Pier took sixteen months to complete.

Overleaf: Santa Monica's most talked-about public utility, the Municipal Pier, on opening day, September 9, 1909.

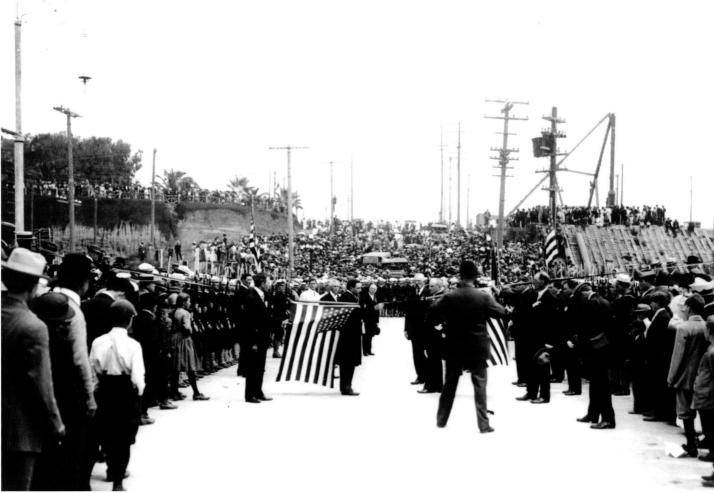

imagine this pier as anything less than a fanciful getaway? Ironically, its original purpose was far from magical—it was born as a simple public utility. The growth of Santa Monica in the early twentieth century forced the city to confront a very serious sewage disposal problem. After considering several options, officials agreed that the best method was to cast it out to sea. But since Santa Monica was already so well known for its beautiful, clean beaches, the notion of polluting the community's own water was preposterous. Careful studies, however, concluded that a pier could carry the waste far enough past the surf that it would wash out to sea, not back to the shore. Property interests in the Colorado Avenue area allowed the City to use their land, and the City immediately proceeded to build a long pier.

September 9, 1909. Opening day of the Municipal Pier featured speeches by Mayor T.H. Dudley and State Senator Lee C. Gates. Opposite: Festivities began with a morning parade from Santa Monica City Hall onto the deck of the new pier.

L.G. Osgood, owner of the California Ornamental Brick Company, recommended using concrete to construct the pier. Wooden piers were notorious victims both of the weather and of infestation by wood-burrowing clams called shipworms or teredo worms. Osgood pointed out the successful use of concrete piers in Europe and in Atlantic City, New Jersey. The City Council concurred, proposing the first concrete pier on the West Coast. On September 28, 1907, the public voted in favor of a \$150,000 bond to build the pier.

Of eleven plans submitted for the new pier, the City Council chose local architect Edwin H. Warner's design, which proposed a 1,600-foot-long pier supporting an eighteeninch outfall pipe running underneath the entire length of the pier's floor, inclined so that gravity would carry the treated waste to the ocean. The plan included a treatment plant on the beach at the foot of the pier, designed to purify the sewage and pump it into the outfall pipe for disposal.

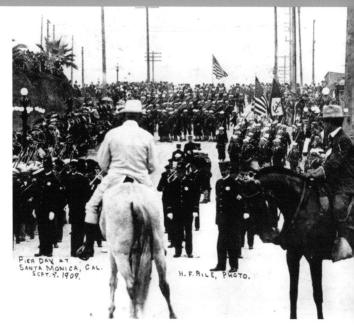

The construction contract was awarded to the Stutzer Cement and Grading Company of Venice, and on April 8, 1908, work began with casting the concrete piles. Materials were readily available, for there was certainly ample sand for the concrete mix. Pile driving began in May 1908, and construction progressed rapidly, at the rate of four piles per day. Journalists arrived from across the country to observe the construction of the West Coast's unique new concrete pier and, in turn, became well acquainted with the charming seaside community where it stood.

Santa Monica was abuzz over potential activities and enterprises that the pier could accommodate. Proposals ranged from a simple bandstand to a highly ambitious yacht harbor. The City Council, also recognizing the potential, yet concerned over growing frustrations with local alcohol use, passed an ordinance outlawing the distribution of liquor on the new pier. Regardless, the members reasoned, the new pier was bound to become an inviting new destination.

On August 18, 1909, after sixteen months of construction, the new pier was completed with only a few minor finishing details remaining, and Mayor T.H. Dudley declared September 9—the anniversary of California's statehood—the official opening day of the new Santa Monica Municipal Pier.

Thousands of people from all over Southern California attended the grand opening and dedication ceremony, a full day of festivities and activities commemorating the City's magnum opus—the West Coast's first concrete pier. The celebration commenced with a parade that began at Santa Monica City Hall and ended at the foot of the new pier, where Mayor Dudley dedicated it and the featured speaker, State Senator Lee C. Gates commended the citizens of Santa Monica for their energy, spirit and courage for using groundbreaking technology. Santa Monica, he declared, had set the precedent for all future piers.

The celebration progressed throughout the day with swimming, running and boating competitions. George Freeth, one of Southern California's first lifeguards and recognized as "The Father of Modern Surfing," was among

The Early Years

"We congratulate you, those of you who are residents of the City of Santa Monica, we congratulate you upon your public spirit, we congratulate you upon your courage, we congratulate you upon your energy and your foresighted spirit in building here this

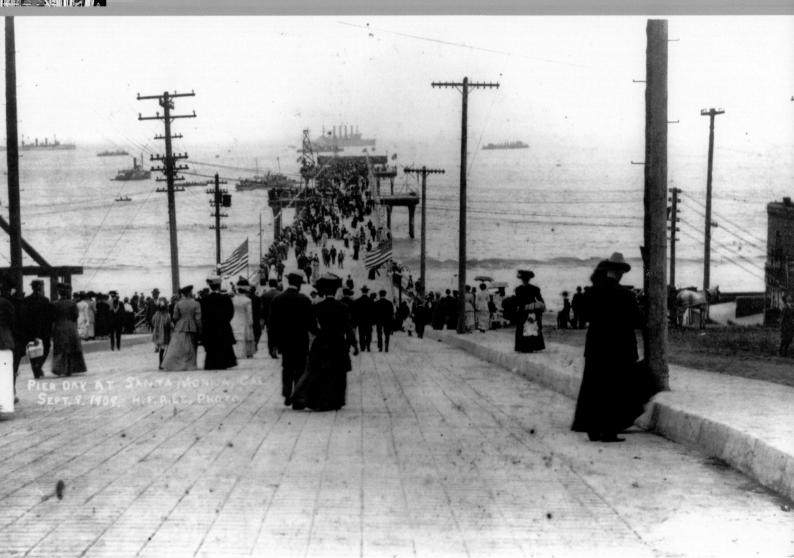

the judges for the day's contests. The naval cruiser *U.S.S. Albany* and her accompanying flotilla dropped anchor off the end of the pier to honor the celebration as crowds gathered to view the great vessels up close. That night, a band concert continued the celebration, and a *tableau vivant* entitled *The Surrender of Rex Neptune* brought the party to a climax. The theatrical production portrayed a battle of wits between the notorious sea-lord Rex Neptune and Queen Santa Monica, whose new concrete pier was strong enough to withstand any of Neptune's legendary storms. Fireworks highlighted the defeated Neptune's fiery descent back into the sea.

Thousands of people set foot upon the new concrete pier on opening day while a United States naval flotilla anchored just beyond.

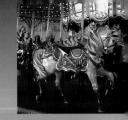

THE SURRENDER OF REX NEPTUNE: A TABLEAU VIVANT

eptember 9, 1909. The great Rex Neptune climbed upon the newly built pier in Santa Monica, California, determined to demonstrate his command over the sea and all those who trespass upon it. Queen Santa Monica, undaunted by the great sea-lord's ominous presence, inquired why he would dare interrupt this glorious public gathering. He had the reputation, after all, of destroying so many prized piers throughout his storied career. Neptune casually replied that destroying piers simply amused him, and that he would take special delight in destroying this new, unusual-looking structure. The Queen scoffed at him, announcing that this pier was made of concrete-impossible even for him to destroy. Neptune surveyed the strong stone-like structure, humbly turned toward the Queen and admitted defeat. The Queen ordered him back to his ocean home, never to return to this indestructible pier, and Rex Neptune dove off the pier covered in a blaze of flames.

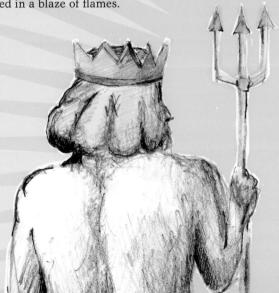

Postcards originated in 1898 as "private mailing cards" and provided room for a handwritten message on one side. They quickly became popular as holiday cards, then evolved into scenes depicting travel destinations. Today old postcards like these stir up a frenzy among collectors.

The Early Years

"With the completion of its magnificent pier at Colorado Avenue—boasted the finest of its class in the world—the old town of Santa Monica has awakened with a jump from a restful slumber."

—Los Angeles Times, October 3, 1909

Pier to find its most exuberant and loyal fans: the fishing community. The first fish caught on the pier was actually landed by John McCreery on August 30, 1909—a full week before the pier officially opened. The new pier was instantly touted as the best fishing spot on Santa Monica Bay.

During the decade that followed, the Municipal Pier remained a very popular destination. Neighboring amusement piers may have been flashier and more alluring, but the Municipal Pier remained distinctly original. The "indestructible" new technology, however, proved less than its billing. On August 17, 1919, a sizable crowd, including Mayor Samuel L. Berkley, gathered at the west end of the pier for passage to

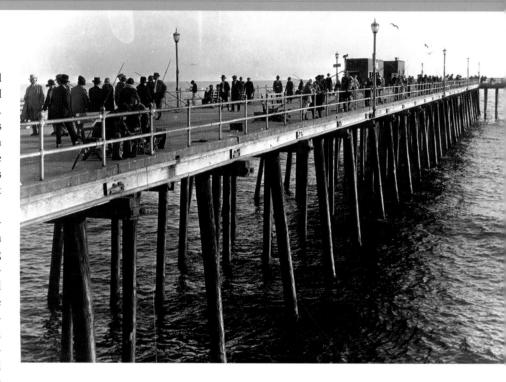

tour the battleship *U.S.S. Texas* and cruiser *U.S.S. Prairie*, both anchored in the bay. Suddenly, a twenty-foot section on the north-end side of the pier shook, groaned, and then dropped approximately two feet toward the ocean. Although no one was hurt, the City closed the pier immediately.

Officials initially blamed the incident on drifting wreckage from the Long Wharf, once a mile-long pier a few miles north, which had inflicted damage two years earlier. Inspection by commissioned engineers, however, revealed that most of the venerable concrete pilings were on the verge of collapse due to rust and disintegration. Further inspection showed that fewer than ten percent of the pilings were sound. The engineers determined that the beach sand used in the initial composition of the concrete was too porous and permeable, compromising the structural integrity of the piles. After careful consideration, City Commissioner William H. Carter recommended that the most suitable replacement would be creosote-treated wooden piles and substructure. Treated piles were believed to be equally long-lasting and certainly less expensive than concrete.

A \$75,000 bond issue was placed upon the ballot with strong support from Mayor Berkley. The *Evening Outlook* added its support as well, expressing its opinion on the matter in no uncertain terms:

SHOULD DISASTER COME TO THE MUNICIPAL PIER . . . SEWAGE WOULD FLOW DIRECTLY INTO THE OCEAN ON OUR IMMEDIATE SHORES AND DISEASE AND DEATH WOULD SURELY FOLLOW IT.

The bond passed by a two-thirds majority on January 1, 1920. Replacement of the concrete piles com-

menced almost three months later. Holes were cut into the concrete floor of the pier, through which new wooden piles were driven. The holes were subsequently patched with new concrete. The process, so novel that *Popular Mechanics* magazine featured it, was completed on November 17, under budget by fifteen thousand dollars.

The Municipal Pier re-opened to the public in January 1921, a little less remarkable than it had been. Then, in 1928 the Municipal Pier lost its distinction as a public utility when Santa Monica joined neighboring Los Angeles and Venice in a new sewage disposal project that transported the west side's waste south to the new Hyperion sewage treatment plant in El Segundo. Finally, in the early 1930s, even the concrete deck was replaced with wooden planks. Yet, while the Municipal Pier was no longer the marvel so heralded in 1909, it survived as a magnet for fishermen, sea lovers and entrepreneurs.

In 1919 the Municipal Pier's concrete piles were replaced by wooden piles. Holes were drilled through the concrete deck, and the new wooden piles were driven through them, leaving a line of circular concrete patches along the length of the deck.
Opposite: The creosote-treated wooden piles were considered to be just as durable as those made of concrete.

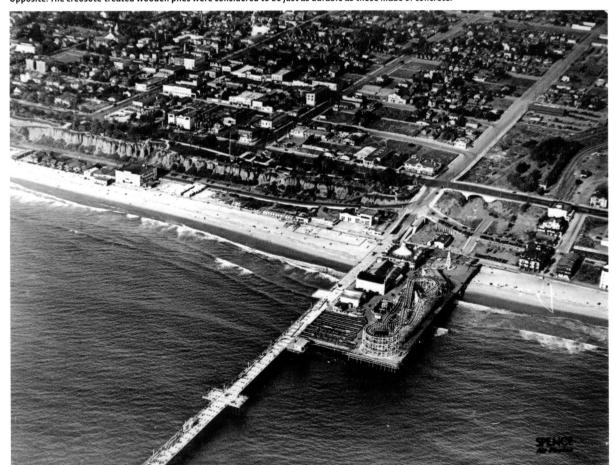

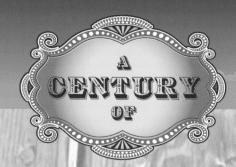

SEA MONSTERS

hat would a seaside community be without a good sea monster story? The first recorded sighting near the pier occurred in September of 1888: a creature resembling a giant black snake was reported about a mile and a half north of Municipal Pier. A more detailed and humorous sighting came in June 1917 as the story of the "Sea Serpent of Santa Monica Pier" took the police, the press and the town by storm:

S-s-s-h!

It was early.

The sea serpent was with us.

It was the real sea serpent, with his flowing mane of green locks. His massive head and trailing body wound in undulating lengths behind him. There was still a little of the darkness of the night before left over, so that the fire the serpent blew from his snake-shaped mouth could be seen. His snakeship, according to the one man and then the other three men, was moving from the north to the south. The more morning broke, the greater in size became the sea serpent. As it increased in size the mammoth head and neck became elevated and began to sway gently from side to side. The tale of what the four men saw was soon being told of as a fact along the oceanfront. It spread to Venice and was told of in Ocean Park. This telephone message was sent to the Santa Monica Police Headquarters: "Reported that a large sea serpent was seen off of the Municipal Pier early this morning." This telephone message was received at the *Outlook* office from Playa del Rey: "Great long string of kelp washed up on beach here. It is believed to have gotten away from the kelp cutters."

[Condensed excerpt from the Santa Monica Evening Outlook; June 28, 1917]

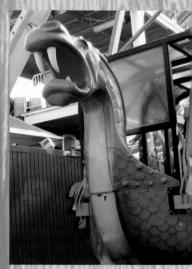

Santa Monica Pier

Carousel Park, as depicted in this sketch, is a tribute to the days when sea monsters were believed to rule the ocean.

Above, left: A clay model for the dragon's head used in Carousel Park.

Right: The Sea Dragon keeps the myth alive as it thrills Pacific Park patrons.

Birth of the Amusement Pier

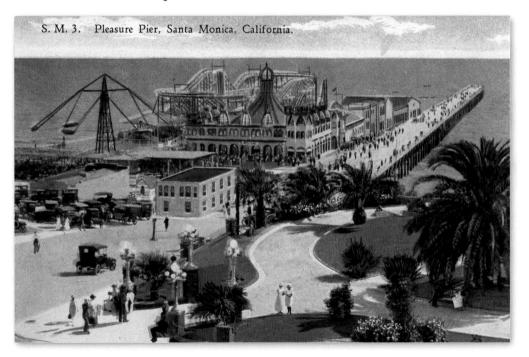

n the early part of the twentieth century, a multitude of seaside amusement piers in the Ocean Park and Venice areas beckoned hordes of people to the beach, adding to the allure of Santa Monica Bay. Ever since the completion of the Municipal Pier, Santa Monica's north beach community yearned to have its own amusement pier, and the most suitable location would be adjacent to the existing concrete pier.

At the time, the property next to the Municipal Pier was owned by Carl F. Schader to the north and Edwin P. Benjamin and B.N. Moss to the south. Benjamin and Moss were first to act. On December 4, 1915, the pair applied to the United States Engineer with a request to build a seven-hundred-foot amusement pier on their property. Two months later, having received approval, Benjamin announced that the company had sold the property to Charles I.D. Looff, a nationally known and respected amusement park entrepreneur ideally suited to completing the proposed venture. The citizens of Santa Monica lauded the announcement and welcomed Looff to the community.

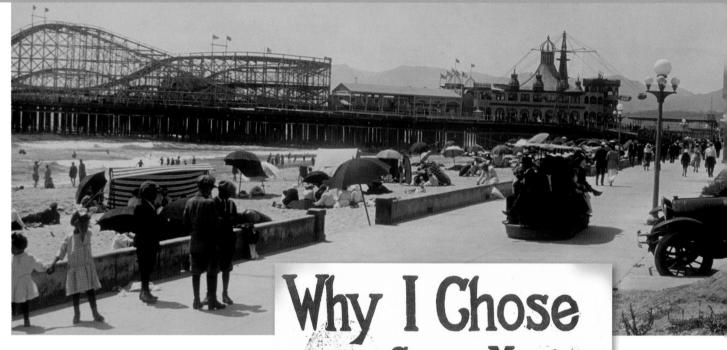

Looff's fame as an amusement entrepreneur found its seeds in New York City some forty years earlier. Born in Denmark, Looff immigrated to the United States in 1870, trained and found employment as a furniture carver. Aspiring to a more creative use for his talent, he began carving wooden animals and, in 1876 at the age of twenty-four, built an all-wooden carousel and installed it at Balmer's Bathing Pavilion at Coney Island. It was the first carousel at the legendary amusement area. Looff continued with a career in manufacturing carousels and other amusement rides, and in the early 1900s moved to Long Beach to tackle the growing West Coast market. After purchasing the property south of the Municipal Pier, he engaged his two sons, William and Arthur, to run the project. Arthur, a trained engineer, supervised all construction; William oversaw more intricate aspects such as electricity and lighting installation.

Pacific Electric Railroad (Air Linc) terminal on property and other main lines in front of property on Ocean Ave. Santa Monica Municipal Pier adjoins property and automobile speedway being constructed through property.
Lots can be bought on very

reasonable terms.

Business Reasons That Caused Chas. I. D Looff to Build His Largest Amusement Pier at Santa Monica.

For 25 years I have been a student of

Before I selected the location of the Loof.
Santa Monica Amusement Pier I studied every
amusement center in Southern California. I analyzed conditions and developments back of every beach.

I selected this location and bought the

the bathing beach at Santa Monica as one of the finest on the Pacific Coast.

-it attracts the highest class of people.

-transportation facilities afforded are une on all sides of the property are high-class i

-an amusement pier at this location w the most profitable crowd of pleasure se diately adjoining and connecting wir Monica's Municipal Pier-1600 feet

Moneta s Municipal Firet—1000 feet in the Jasty, and most important, there is back "off property a real substantial city with fine by orards connecting Los Angeles and such we suburban communities as Hollywood, Bre Hills, Brentwood Park and the Wilshington, it being the nearest beach to "all this limit of the Hills, Brentwood Park and the Wilshing tion, it being the nearest beach to "all this limit of the Hills, Brentwood Park and the Wilshing the nearest beach to "all this limit of the Hills," and the Hills, Brentwood Park and the Wilshing the New York and the New York and

(Signed) CHAS. L.D. LOC

"The merry-go-round makes me smile at memories of thirty years of kids wide-eyed with joy. The Pier is an indispensable bridge between the land and sea, people and natural ecology, the urban and the wild. May it bring peace to many future generations."

—Tom Hayden, political activist/politician, 2008

Benjamin and Moss further developed the remainder of their south-side property, adding a team of electric tramcars designed to traverse the promenade along the beachfront and to carry passengers from Red Line terminals at Hill and Main Streets in Los Angeles. They convinced Pacific Electric to establish an Air Line train terminal at the foot of the Looff Pier property. The popular Air Line was, at that time, the only train which took its passengers directly to the beaches, and the proposed location of the terminal greatly influenced Looff's decision to build in Santa Monica.

Construction on the new pier proceeded quickly. In the meantime, Charles Looff negotiated with the City for a proposed twenty-year franchise for the new pier and announced his intention to attach his amusement pier to the Municipal Pier, enabling easy access between the two. The Santa Monica Planning Commission approved the concept and, after much debate, the Looff proposal was finally accepted with the caveats that the City be fairly compensated and that an anti-liquor clause be added to the agreement since the pier had always been dry. The Looffs agreed, and the franchise was formally sold to them on June 1, 1916.

The new pier began to take shape in early June. The framework for the pier's roller coaster became visible and the carousel building, named the Looff Hippodrome, was nearly complete. The Hippodrome got its unusual name from the Greeks—hippodrome is Greek for "horse racecourse." Wooden animals lined up inside the building, waiting to be mounted on the circular platform. On June 12, 1916, the carousel opened temporarily for a weekend, drawing people from all over Santa Monica. The following Fourth of July weekend was so busy that the still-

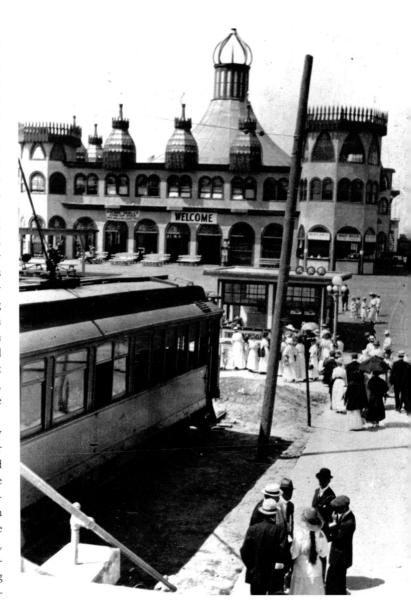

An ideal location for the train to stop, the Looff Pleasure Pier enjoyed large crowds departing from the Pacific Electric Air Line. Opposite: Accessibility was among Charles Looff's primary reasons to build a pleasure pier adjacent to the Municipal Pier.

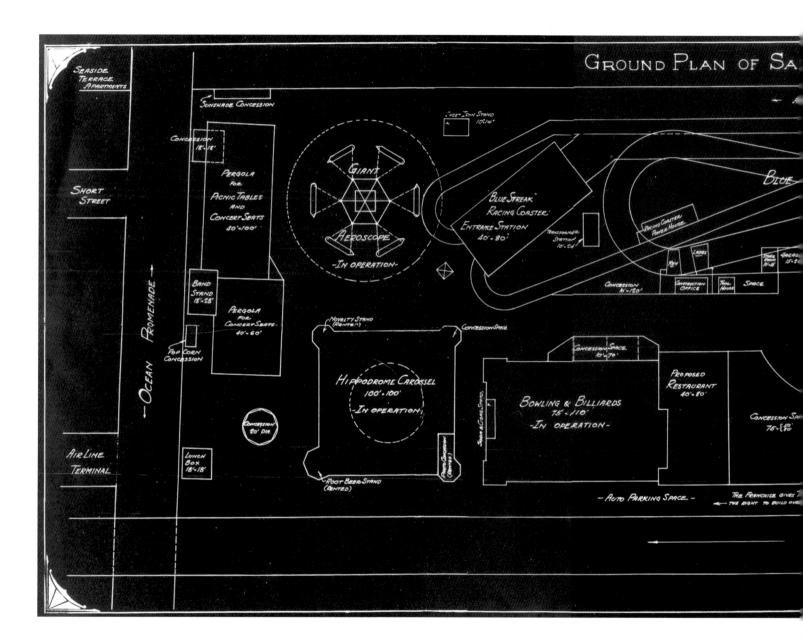

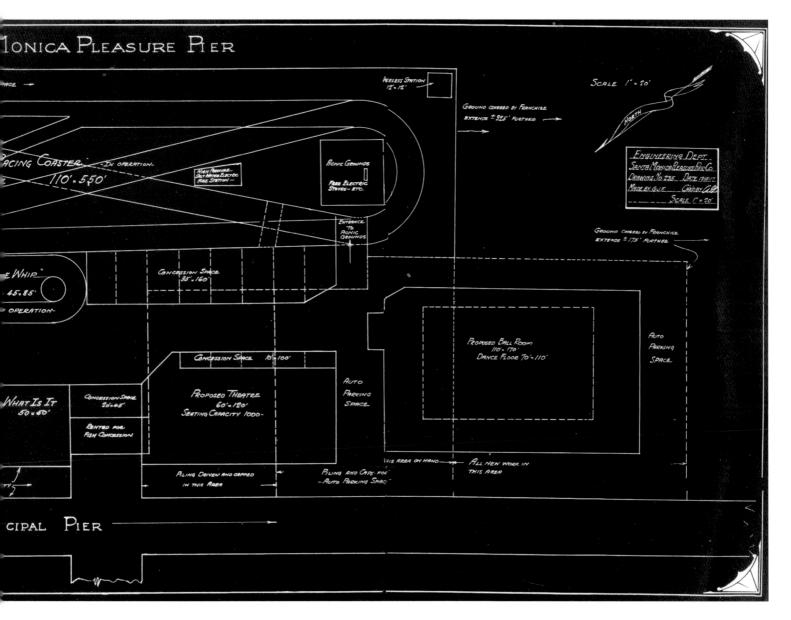

The Looff Pleasure Pier plans included a roller coaster, thrill rides, a carousel, bowling and billiards, all of which were in full swing by 1917. Plans for a theater and ballroom were also included, but never completed as part of the Looff Pier.

unfinished Looff Pleasure Pier was clearly going to be the most popular pleasure pier on the entire West Coast.

On August 3, 1916, the first screams were heard accompanying the roar of wheels speeding along the tracks of the Blue Streak Racer, the new roller coaster on the Looff Pleasure Pier. The screamers were carpenters and laborers who worked hard to construct the pier—that first ride was their reward. The following day the coaster opened to the public and the City held a grand opening ceremony to congratulate the Looffs for their efforts.

The new amusement pier included a picnic area at the foot of the coaster, complete with electric ovens.

This picnic area was but a prelude, the Looffs announced, to a full-scale picnic pavilion planned for the pier's eastern end. More thrill rides were on tap; the Whip and the Aeroscope each opened within a month. In January of 1917, the Bowling & Billiards Building opened, and its alleys and tables were an immediate success. In the spring, the anxiously awaited fun house named "What Is It?" opened its doors. Inside, patrons walked through several levels

of sight-and-balance gags such as shifting stairs and moving floors, culminating in a seventy-foot slide.

As promised, the new picnic pavilion was ready by late May. Picnic tables were arranged under a wooden canopy covered with palm leaves to provide shaded dining. The nearby bandstand was an ideal venue for weekend concerts. Professor Caesare La Monaca and his Royal Italian Band, one of the most popular bands on the Pacific Coast at the time, headlined at the Looff Pavilion on June 2, 1917, and performed as many as three shows a day. The Santa Monica Municipal Band later divided its time between the Looff Pleasure Pier and Ocean Park.

In December of 1917, Charles Looff sold stock in his new firm, the Santa Monica Pleasure Pier Company. The

Tang Plan Santa Massics Call

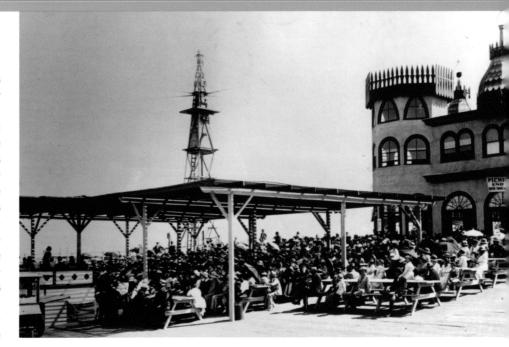

Crowds enjoyed the variety of amenities offered by the new amusement pier. Above: The picnic pavilion and bandstand were completed in May of 1917 and became a favorite venue for weekend band concerts.

stock initially sold well, and expansion quickly began. A twostory banquet hall went up just west of the Bowling & Billiards Building, and was ready March 15, 1918, in time to host its first of many groups, the Christian Endeavor Convention.

The Looff Pleasure Pier thrived during its first couple of years, and plans were developed for continued expansion of its

amusements, including an extension of the pier to accommodate a large ballroom. After Charles Looff's death in the summer of 1918, however, the optimism surrounding the pier began to fade. The company's stock collapsed;

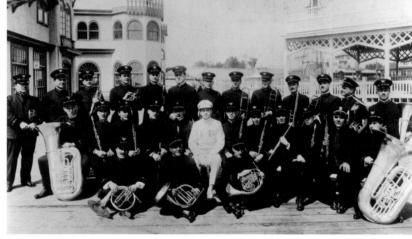

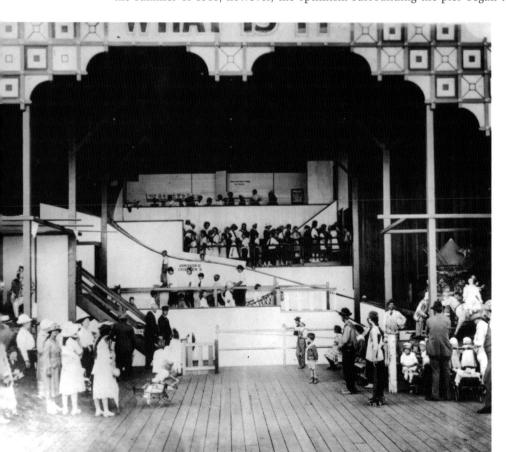

controversy over the Municipal Band splitting time between the Looff Pier and Ocean Park jeopardized concerts altogether and Arthur Looff ultimately began spending the better part of his time and energy developing amusements for the Santa Cruz Beach Boardwalk. In January of 1921 rumors circulated about the sale of the amusement pier. On September 14, 1923, it became official-the Looff Pier was sold to the Santa Monica Amusement Company, a syndicate composed of prominent local real-estate investors Edward B. Conliss, C.D. Terry, David D. Pascoe and Dr. Frank J. Wagner.

"What Is It?" was the Looff Pleasure Pier's funhouse. Patrons were treated to sight gags and shifting floors on a walking tour that culminated with a giant slide.

Above: Professor Caesare La Monaca and his Royal Italian Band. La Monaca was known not only for his musical prowess, but for his extensive collection of band uniforms.

POPEYE

opeye was a regular on the Santa Monica Pier. It's true! His creator, Elzie Crisler, aka E.C. Segar, visited the pier daily in the 1920s and '30s, renting a skiff upon which he and his assistant would discuss story ideas for his King Features comic strip, *Thimble Theatre*. Each day they encountered Captain Olaf C. Olsen, a big-hearted retired sailor whose wardrobe and smoking pipe caught the eye of the popular cartoonist. While the real-life inspiration for Popeye is often credited to Frank "Rocky" Fiegel, a memorable ruffian from Segar's youth in Illinois, one glimpse of a photo of Olsen clearly shows the physical inspiration.

A remarkable man in his own right, Olsen was born in 1879 in Norway, where he grew up aboard sailing ships. He immigrated to the United States as a teenager and joined the U.S. Navy. After finishing his service, he continued sailing until he settled in Santa Monica in 1925. He bought an old whaling ship called the *Narwhal* and converted her to a fishing barge, the first in a fleet of barges, day-boats, and water taxis that he operated from the

pier. He became an instrumental figure in the early development of Santa Monica Bay's pleasure fishing industry.

Olsen was passionate about the rights of sport-fishermen and the health of the local ecosystem. In 1928 he led the first campaign to protect marine life in Santa Monica Bay. Commercial fishing boats, he feared, were on the verge of wiping out the population of local fish and upsetting the bay's ecological balance. His crusade initially resulted in a ban on net fishing and ultimately in a ban on all commercial fishing in the bay.

In the early 1930s, the City granted Olsen a franchise to manage all boating operations on the Municipal Pier, a very important position given the popularity of sportfishing. A compassionate man, he invited men from the Unemployed Citizens League to fish for free from his boats and barges during the Great Depression. When he could, he donated a percentage of his own catch to those in need. His big heart overshadowed his business sense, however. In three and a half years of management, Olsen never once paid rent, and the City revoked his franchise. Despite his ouster, he remained a vivid presence on the pier and in the local sportfishing scene. Like any fisherman worth his salt, he was never without a good story, and bent the ears of children and adults alike until he passed away in 1950.

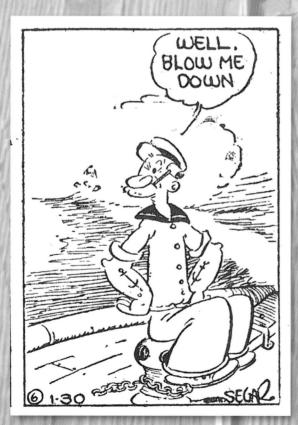

28

Santa Monica Pier

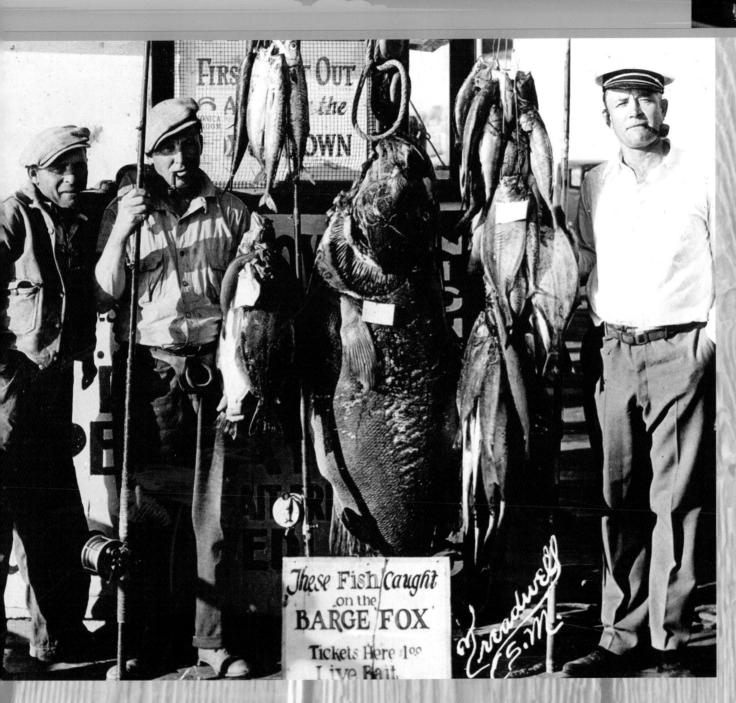

Captain Olaf C. Olsen (right) was the most passionate fishing aficionado in early Santa Monica Pier history. He was also the most recognizable.

Opposite: When Santa Monica resident E.C. Segar created his popular comic-strip character "Popeye," it was easy to see who he used as the model.

Expansion and Contention

Puit 2

A Succession of Suitors

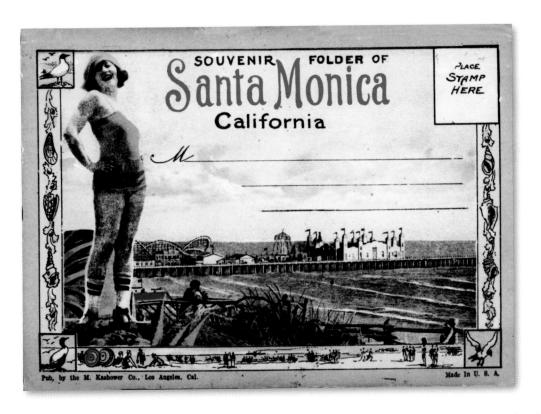

he first priority for the Santa Monica Amusement Company was the replacement of the aging Blue Streak Racer. The firm hired the Whirlwind Dipper Company to construct a new roller coaster designed by the Prior & Church Company, owners of many of the rides in Venice and Ocean Park. Construction went quickly, and the new Whirlwind Dipper coaster opened its gates on March 30, 1924.

With the new coaster fully operational and successfully drawing people to the pier, the company turned its attention to its next great enterprise—the La Monica Ballroom. The plans were drawn by the internationally

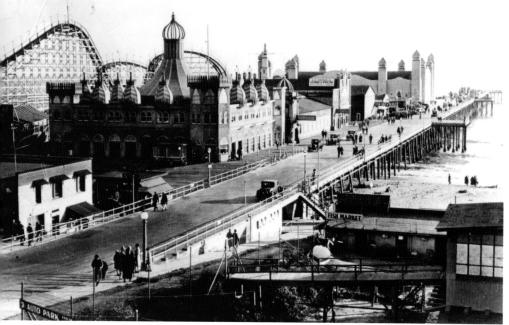

renowned T.H. Eslick, an architect who had achieved an impeccable reputation designing grand ballrooms in the United States, Europe and Australia. Construction on the gigantic structure moved at an accelerated pace, with the La Monica scheduled to open in the early summer. Newspapers in both Santa Monica and Los Angeles steadily monitored its progress. On July 23, 1924, more than fifty thousand people arrived to witness the opening of the La Monica Ballroom, a crowd so immense that the event has since been credited with causing Santa Monica's first traffic

jam. The La Monica was considered the most impressive structure of its kind, and became an instant success.

By 1925, though, business on all of the Santa Monica Bay's piers began to wane, a phenomenon credited to the recent availability of inexpensive used automobiles. Worsening matters for the Santa Monica Amusement Company, a storm rocked the pier and the La Monica, causing significant damage to the substructure and forcing the ballroom to close for repair. After the ballroom recovered, the Whirlwind Dipper faced near-disaster when a nineteen-year-old woman leaped off while it was nearing the end of a run. Admitting that she had been drinking with a few companions, the girl was lucky to suffer only a broken arm, some internal injuries, and cuts and bruises. The publicity did not help an already struggling operation, however. On September 1, 1927, Conliss, Terry and Pascoe of the Santa Monica Amusement Company sold all of their interests to a newly formed syndicate, the Santa Monica Pier Amusement Company, headed by continuing owner Dr. Frank J. Wagner.

Among Dr. Wagner's first projects was the construction of a 150-foot extension to the southwest corner of the pier, just beyond the ballroom. The extended section was built in order to accommodate a new tenant, the Santa Monica Yacht and Motorboat Club, and resembled a third pier.

In late May of 1928, Dr. Wagner leased his concession rights to the Laumauro Amusement Company of New York. The new lessee invested one million dollars (over twelve million dollars in today's dollars) into the creation of a theme park called "The City of Bagdad." The park was extensively redecorated to reflect the atmosphere of the old Eastern world and opened on June 30, 1928. Merchants in "The City of Bagdad" wore Arabian dress and, for ambience, a hunchback minstrel played Middle Eastern music. An Eli 24 Ferris wheel carried patrons high above the ocean, providing a magnificent view of both the replica Arabian city below and the real host city above the palisades to the east. As a complement to the themed park, the Santa Monica Yacht and Motorboat Club offered

Edward B. Conliss, Pier owner/partner from 1923 to 1927, September 14, 1923

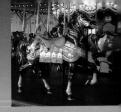

moonlight rides near the pier.

Unfortunately Dr. Wagner passed away just days before the opening of "The City of Bagdad." His widow, Lulu D. Wagner, assumed controlling interest of the pleasure pier. With no amusement experience to speak of, she immediately searched for someone to manage the Santa Monica Pier Amusement Company. In July 1928 she found Ernest Pickering.

Pickering was a familiar face in the area's amusement pier business, having been involved in amusement parks in Venice, Ocean Park and San Bernardino. When Mrs. Wagner enticed him to Santa Monica, he marveled at the city's growth. He was instantly eager to assume management of the pier, which he referred to as the La Monica Pier to honor the pier's most notable attraction.

The pier's Arabian theme was short-lived, and the pier eventually returned to a more traditional setting. Within a year, Pickering shifted the amusement pier's focus toward children. With sponsorship from the Santa Monica Evening Outlook, he organized beach parties on summer Saturdays, including free access to all of the amusements on the La Monica Pier. Featured entertainment included a "Punch and Judy" puppet show, night-time movies, and a high-diver who made a ninety-seven foot leap—complete with a back flip—into a tank of water.

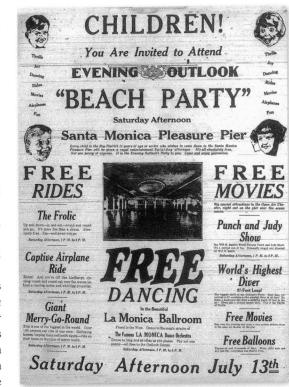

In the winter of 1930, the Depression hit the pier. Unable to support the cost of its own maintenance, the Whirlwind Dipper was removed. Pickering, refusing to be discouraged by the nation's economic hardship, turned his focus to methods that would keep his amusements popular—and in place. In September of 1931, the La Monica Pier hosted a fashion show and benefit to aid people on welfare.

In April of 1931, Lulu Wagner and Pickering negotiated a twenty-one-year extension of the La Monica Pier's franchise. Two months later, they leased the pier to the Los Angeles Concession and Novelty Company, which focused on catering to the anticipated yacht harbor. Throughout the rest of the 1930s, the amusement pier was but a shell of itself, with little to qualify as "amusements." Wagner and Pickering repeatedly and unsuccessfully tried to sell the property to the City. Ultimately they defaulted on their franchise lease, and Security-First National Bank took over the property. The City considered purchasing the pier from Security-First, but the ownership of the pier was tied up in legal red tape until the 1940s.

35

Expansion and Contention

Pleasure Pier manager Ernest Pickering organized spectacular Saturday afternoon beach parties at the Pier in 1929.

Opposite: In 1924 the Santa Monica Pleasure Pier upgraded and expanded to include the new, faster Whirlwind Dipper roller coaster and the enormous La Monica Ballroom.

GOOD NEIGHBORS

he pier has become such a landmark that the surrounding neighborhood has essentially become a part of it. Traditional activities ranging from two-person beach volleyball to eating a hot dog on a stick claim their roots near the pier. Likewise, organizations have wisely attached themselves to Santa Monica's famous landmark.

Beginning in the 1930s, the fitness routines and acrobatics of Muscle Beach attracted awe-struck crowds just south of the pier, and continued to do so for the next two decades. Those same oohs and aahs could be heard many years later as *Cirque du Soleil* mesmerized audiences in the north beach parking lot. The pier was the first United States location of the *Cirque*'s famous touring show. Other major shows have since followed in those footsteps, including *Cirque*'s equestrian cousin *Cavalia* and the traveling photographic art show "Ashes and Snow."

The City boldly placed Artist Carl Cheng's sculpture *Walk on LA*, a giant rolling pin with the city structures and freeways carved into it, on the beach north of the pier in 1988. It has attracted curious onlookers ever since. Once in a while the sculpture even rolls its imprint of the City onto the beach, giving onlookers the chance to live up to the sculpture's name.

In 2003 Cheng's sculpture was joined by an artistic statement with a much more somber tone. Shortly after the outbreak of the Iraq War, Veterans for Peace began erecting crosses on the beach every Sunday. Initially, each white cross represented one soldier who had died in the Iraq War, but soon hundreds of red crosses each commemorated ten fatalities, a dramatic statement on a peaceful beach. What began as a short-term demonstration became a regular reminder of the hard realities of the world away from the pier.

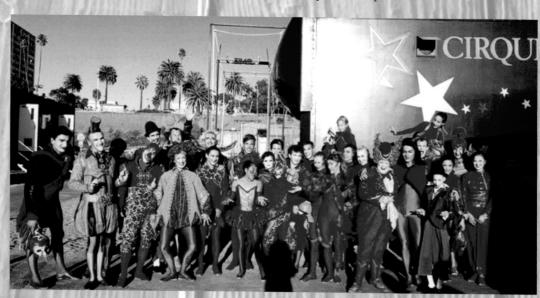

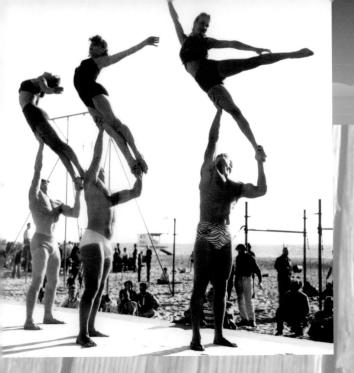

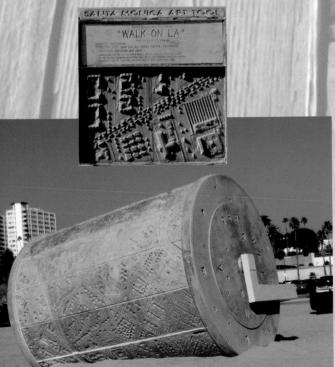

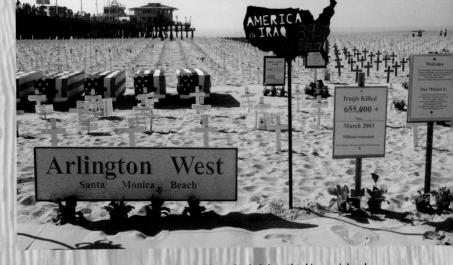

Clockwise from top left: Spectacular gymnastic shows made Muscle Beach world-famous; Cirque du Soleil brought their breathtaking aerial and floor acts to the pier throughout the 1980s and '90s; Arlington West pays tribute to the sacrifices made in overseas wars; the Carl Cheng sculpture can roll the city on the beach so that people can Walk on L.A.

Opposite: The cast of the original touring production of Cirque du Soleil in 1988.

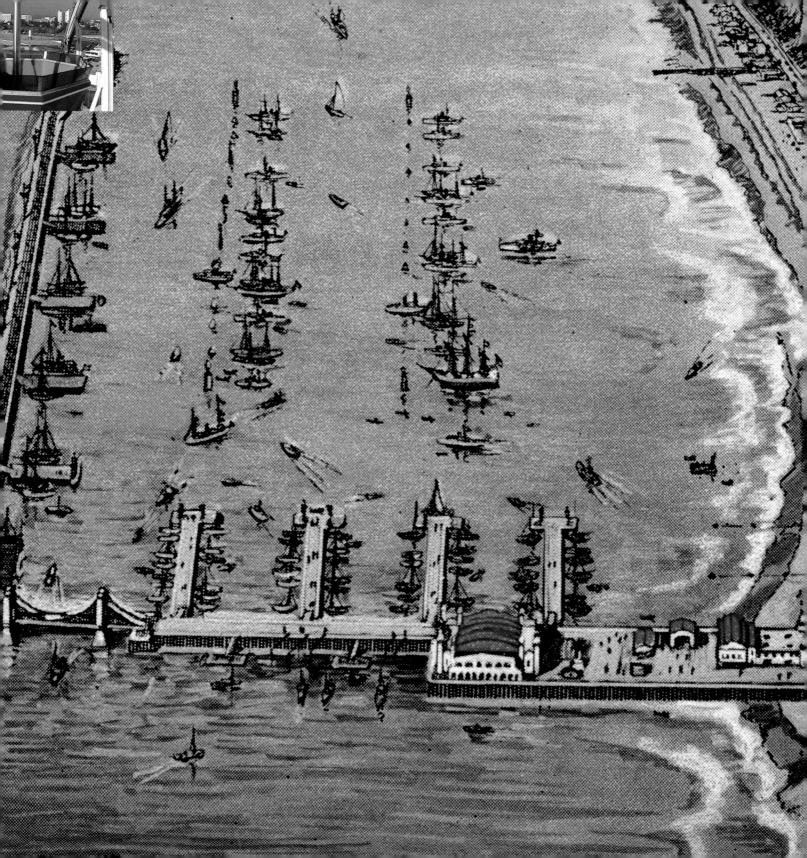

Launching a Yacht Harbor

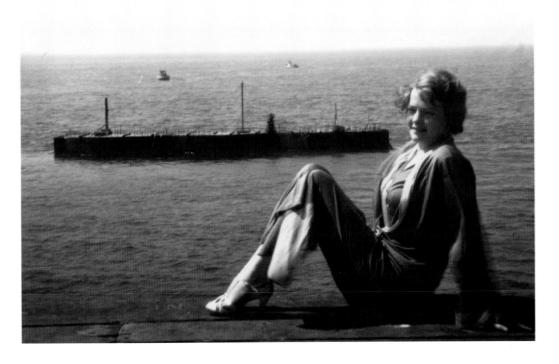

reams of a yacht harbor had always danced in Santa Monicans' heads. Plans were drawn up several times only to founder before any real progress was actually made. Finally, in 1926, a group of businessmen formed the Santa Monica Breakwater Association and gained enough momentum to ask for state approval of breakwater and harbor construction.

In April of 1929, the Breakwater Association lobbied the California State Senate to pass the Harbor District Bill—legislation that would allocate funding for the proposed breakwater. The bill required the signature

A woman sits on the west end of the Municipal Pier in March 1933 with the newly placed first concrete caisson of the Santa Monica Breakwater in the background. The caisson later failed, and the project was altered to use a rock-mound construction instead.

Opposite: An artist's rendition of the proposed Santa Monica Yacht Harbor.

of Governor Clement C. Young, and confidence was high that the project would move forward quickly. Enter the associates of newspaper magnate William Randolph Hearst, who were developing their own plans for a commercial harbor further up the coast and feared that a Santa Monica Yacht Harbor could poten-

tially evolve into a commercial port. Despite strong assurances from the Breakwater Association that the harbor would not seek

commercial interests, Governor Young vetoed the bill.

Undaunted, breakwater proponents persevered. An existing harbor bill still allowed for the construction of a small boat harbor with the support of public bonds. In June of 1930 the Santa Monica City Council unanimously voted to build a breakwater and small boat harbor. Engineer Taggart Aston designed a breakwater that employed a series of sand-filled concrete caissons, each one hundred feet long, placed adjacent to one another to form a two-thousand-foot breakwater towering fourteen feet

The Breakwater Will Relieve Unemployment In All the Bay District!

The or has the seed at the seed at

above the water line. The plans also called for an extension of the Municipal Pier and a bridge connecting the pier to the breakwater, allowing pedestrian access to it.

In September 1930 the Santa Monica Harbor Company, Ltd., was incorporated with an authorized capitalization of \$2.5 million. Work began on October 28, 1930, with the extension of the Municipal Pier. The city held a ceremony for the commencement of the much anticipated project, and ninety-four-year-old Mrs. D.G. Stephens, one of the bay area's first residents and known locally as the "Mother of Santa Monica," directed the driving of the first pile. Mayor Herman Michel christened the pile with a soft-drink bottle, and later that night fireworks illuminated the sky.

By mid-February 1931, though, progress on the project came to a halt. The Santa Monica Harbor Company reported that its expected funding had fallen through. The potential default left officials debating whether or not the City should build the breakwater. Earlier that month the Santa Monica-Ocean Park Chamber of Commerce had reapplied to the State for an enabling act through which the breakwater could be financed. As if answering the City's prayers, the act passed the legislature and was signed by newly elected Governor James Rolph, Jr., on June 18, 1931, allowing Santa Monica to issue a district bond. A \$690,000 bond measure was passed by popular vote on September 12, 1931, enabling the City to move forward with construction of the yacht harbor, and the franchise contract with Santa Monica Harbor Company was canceled. The City chose to move forward with Taggart Aston's design for the breakwater.

The dock and forms were completed in February of 1933, and the concrete for the first caisson was poured on February 25. After setting and hardening for one month, it was towed to Santa Monica on March 25, two days earlier than expected. A surprised few witnessed the towing and spread the word so quickly that, by the time the caisson was placed, a large crowd had gathered on the end of the Municipal Pier to watch what was regarded as a pivotal moment in Santa Monica's history.

Less than a week later, a crack was discovered on the outer side of the newly placed caisson. Engineers

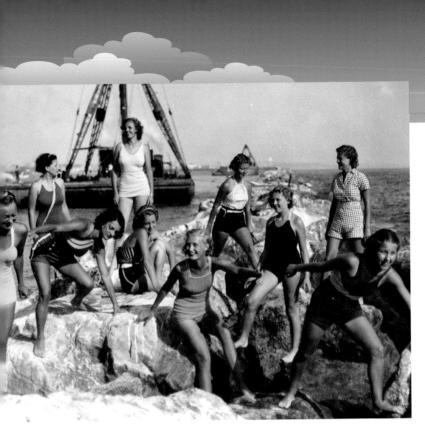

originally thought collision with debris on the ocean floor when the caisson was dropped caused the crack, but further inspection revealed that a strong sea current was the real problem. To make matters worse, the ocean currents had carved out a forty-foot trough on both sides of the caisson's base, causing the structure to settle an extra three feet. Construction of the remaining caissons was put on hold pending further investigation.

The City brought in United States Army Engineer D.E. Hughes to assess the situation. Hughes outlined shortcomings that he saw with the crib-type breakwater and advised building a rock-mound style instead. Taggart Aston defended his crib-type wall, arguing that a rock mound would cost in excess of two million dollars. After researching the project thoroughly, officials determined that a rock-mound seawall was

indeed within the amount budgeted, and on May 26, 1933, the City Council formally approved the changes in the contract with the Puget Sound Bridge and Dredging Company.

Two barges brought the first thousand tons of stone from Santa Catalina Island on July 14, 1933, and deposited their loads into place, followed by a regular schedule of three barges arriving every other day, each carrying five hundred tons of stone. In late September a derrick barge arrived for placement of the heavier rock, called "armor stone," atop the base of the rock wall. By early October the rock wall was finally visible to people looking from the beach and the pier.

On a rainy December 14, 1933, John "Scotty" McPherson accidentally fell into the tow of a 150-ton load of rock as it was poured into place on the rock mound. Only twenty-seven years old, McPherson was a well-liked local fisherman who had taken temporary work on the breakwater to make ends meet. Two days after the accident, a deep-sea diver found his body snagged on the top of the breakwater mound twenty feet below the surface. At the request of the rest of the work crew, arrangements were made to place a bronze memorial tablet on one of the breakwater stones to honor him. Safety measures were tightened and, though there were a couple of other minor accidents as the project progressed, McPherson was the breakwater's single human casualty.

On July 30 the City Council announced the completion of the breakwater, adopted an ordinance for boating regulations, and appointed lifeguard captain George Watkins, Owen Churchill and George Mills to the Harbor Committee. The breakwater completion came just in time. Santa Monica officials, so certain that the breakwater would be complete in the early summer of 1934, had long before agreed to host the first annual Santa Monica Regatta on August 4. The construction barges were quickly cleared for the regatta while the City held a special dedication ceremony for the new harbor.

A group of young women playfully inspect the new rock-mound breakwater shortly before its completion. Behind them is the barge used during the construction of the breakwater.

Opposite: In 1931, the Santa Monica Evening Outlook newspaper ran an aggressive campaign to enlist community support for the breakwater.

THE FAMOUS PLER SIGN

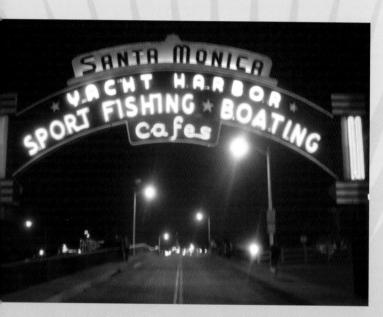

n 1939, work began on the Colorado Grade Separation Project, a complex highway project that was designed to improve access between the Pacific Coast Highway and city streets. The location of the project eliminated the traditional access to the pier, so planners designed a ramp at the end of Colorado Avenue to allow traffic to pass over the new accessways and travel directly onto the pier's deck.

Ground broke for the new pier ramp on September 19, 1939, closing the entrance to the Municipal Pier and tearing up part of the pier's east end. The City, recognizing that business would be severely hampered by the project, reduced rents for businesses on the pier by five percent. Construction took five months and the ramp was opened for use on June 12, 1940.

The new access ramp was not clearly visible, nor was it obvious that it was indeed the correct route to the pier. This was of great concern to the businesses on the pier. With the money saved from the rent reduction during construction, the Santa Monica Pier Business Men's Association committed two thousand dollars to hire the Pan-Pacific Neon Sign Company to design and construct a neon sign and mount it at the top of the bridge.

The arched blue sign—twenty feet at its highest point, twelve feet at its lowest and supported by columns on each side of the ramp—has since become an internationally recognized landmark. In 1996 the State of California Department of Parks and Recreation declared the iconic sign an historic landmark. The official record notes its dual historical significance as: 1) a classic example of signage from the neon era, and 2) the designated marker for the last existing pleasure pier in an area in which they were once bountiful.

Advertising the pier as "Santa Monica Yacht Harbor," the sign's verbiage is a bit misleading today, but for the pier's old-timers it is a memory well worth preserving.

Recognized worldwide as a symbol not only of Santa Monica, but of the Los Angeles area in general, the pier entrance sign refers to a harbor that now exists only in memories and photographs.

Opposite: The pier sign is an extremely popular photo site. Here, the Santa Monica Police Department's Mounted Unit lines up within its familiar frame.

Santa Monica Pier

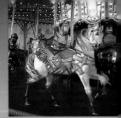

NTA MONICA HT HARBOR SHING * BOAT Cafes

43

Expansion and Contention

The Newcomb Years

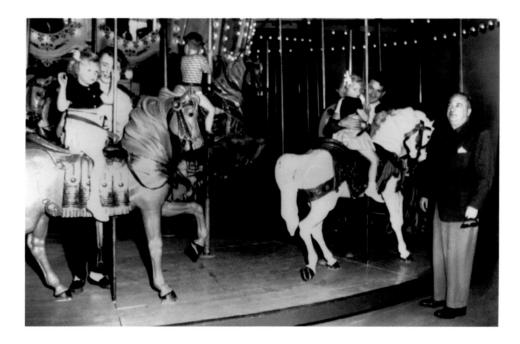

y 1940, the amusement pier faced an identity crisis. It was no longer home to crowds of people laughing and screaming aboard its thrill rides. Instead, the pier found more use as a parking lot bordered by a small collection of businesses. By default, Security-First National Bank held title to the franchise. The bankers continually tried to find suitors interested in purchasing the franchise, but to no avail. They hired Harold Walker, a former officer in the U.S. Navy, to manage the pier, who in turn invited his close friend Walter D. Newcomb, Jr., to be co-manager. At the time, Newcomb owned the Venice Pier Fun House and merry-go-round. When World War II broke out in 1941, Commander Walker rejoined the Navy, leaving Newcomb to manage the pier on his own. A former banker, Newcomb eventually purchased the franchise in March 1943.

Upon purchasing the Santa Monica Amusement Pier, Newcomb boasted that he had big plans for the venue, but since the nation was in the middle of wartime restrictions, those plans would have to wait. The ball-room, restaurants and shops prospered during the war, the residual effect of the high-volume fishing operations on both piers. Newcomb sought to capitalize on the booming fishing industry by adding a new hoist at the end of his

pier, to increase the high volume of production already being shipped through Santa Monica.

When the war ended, Newcomb found himself in an enviable position. The amusement business was expected to see a great surge with the return of the country's military personnel and a general feeling of national pride. Plus, the closure of the Venice Pier reduced his competition. He relocated his Venice-based carousel into the old Looff Hippodrome and focused on maintaining a steady home in his ballroom for an increasingly popular musician named Spade Cooley. He also added some new, smaller rides to accompany his existing penny arcade and gift shop.

In 1952 Newcomb entered negotiations for a new twenty-one-year lease for the franchise, making it easier to secure funding to add new attractions to his pier. The City, acting with wary foresight, inserted the provision that upon expiration of the lease, Newcomb would be responsible for tearing the property down. Newcomb agreed, securing his ownership of the franchise until the early 1970s.

On June 19, 1954, while vacationing in Europe with his wife Enid, Walter Newcomb suddenly died, his hopes of expanding amusement operations unfulfilled. He left his estate, including operation of the pier, to Enid and their two daughters, Elizabeth and Jane.

When it came to the professional world, Enid Newcomb was no novice. In addition to being a wife and mother, she was a college graduate and small-business owner. Prior to Walter's death she operated the gift shop on the pier, and when

Walter passed away, she handled the transition into managing the pier and wrangling with Santa Monica politics rather easily. Still, she recognized that management of the pier was a demanding task, so she sought help from long-time family friend Morris "Pops" Gordon. Gordon was an affluent Santa Monica businessman known for his success with penny arcades and other small enterprises. When he was approached by Mrs. Newcomb, he offered the services of his sons, George and Eugene. The hard-working Gordon sons took over the management responsibilities of the carousel and both penny arcades. Under Mrs. Newcomb's leadership, the pier continued its operations, first under the name of the Santa Monica Pier Company and later as Bay Amusement Company.

Throughout the 1960s and 1970s the Newcomb and Municipal Piers—by then commonly referred to jointly as Santa Monica Pier—were noticeably aging. Compared to neighboring Pacific Ocean Park (POP) pier a mile south and Disneyland in Anaheim, the vintage pier bordered on seedy. Nevertheless, while observers agree that these years were the pier's worst era, they were the years that its character took shape. Artists frequented the pier; some lived in apartments above the carousel and in the old ballroom. People could roam its decks without the assault of flash and action found in amusement parks, but with plenty of sound and energy. The pier had become a small neighborhood hovering peacefully above the sand and sea.

Enid Newcomb, Walter's wife, enjoyed running a small gift shop on the pleasure pier. When Walter passed away in 1954, Enid assumed control of the pleasure pier's entire operation.

Opposite: Walter Newcomb, standing to the right in this publicity photo of the carousel, bought the lease to the pleasure pier in 1943. His family continued to own it for the next three decades. Many people today still refer to the pier as the Newcomb Pier.

45

THE BATTLE OF SANTA MONICA BAY

n Raymond Chandler's 1940 novel *Farewell, My Lovely*, the fictional town of Bay City, based on Santa Monica of the 1930s, is immersed in corruption and gambling, complete with casino barges anchored just off the end of the pier. Not far from the truth. There's been a history of gambling linked to the seaside area, and the pier was no innocent bystander. Tales are still told about games of chance hosted in the secret back rooms of some of the pier's former establishments. One such story tells of a man winning heavily at craps until someone discovered his dice were loaded. The fool was dragged outside and thrown off the pier into the ocean. But Chandler truly captures the era when he writes about the bay's gambling ships, a memorable part of the pier's history.

The first of the Santa Monica Bay gambling barges, the *Johanna Smith*, appeared in the summer of 1929. Anchored thirteen miles off the Santa Monica shore, the commute to reach her via taxi boats from the Venice Pier took nearly two hours. Poor attendance forced the barge out of business. Other barges appeared, then disappeared for various reasons until mobster Tony Cornero arrived with a small fleet of "floating casinos." The most infamous was the *S.S. Rex*.

Rex was no stranger to the area. For many years Captain Charles Arnold operated her as a fishing barge

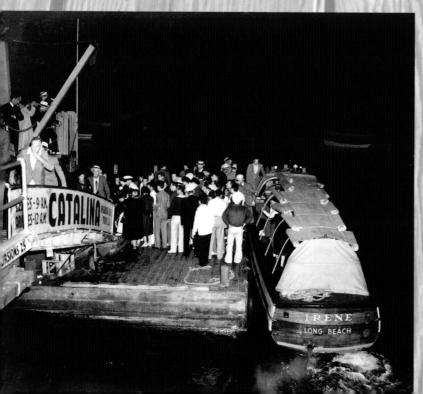

named *Star of Scotland*. In 1938, when Cornero bought her, the mobster converted the ship into a deluxe floating resort and anchored the *Rex* 3.1 miles offshore, just off the end of the Santa Monica Pier, and outside the three-mile legal boundary for gambling operations. A collection of fast shore boats could get passengers from the pier to the *Rex* in about ten minutes. When operations began on May 5, 1938, the *Rex* brought more people to the pier than anyone dreamed.

The City did not share the pleasure of Cornero and his patrons, however. After the Rex opened—and even before—the City fought for months, several times closing off the water taxi operations offered at the pier. After every closure, Cornero managed to find new loopholes that allowed service to the Rex to return to the pier. City commissioners ultimately appealed to District Attorney Earl Warren to intervene.

On July 28, 1939, Warren declared that the legal jurisdiction line for gambling begins not

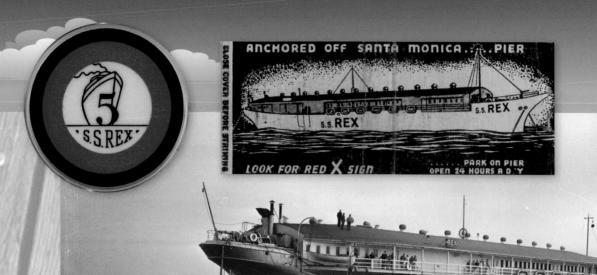

at a distance of three miles from shore, but three miles from an imaginary line drawn from Point Vicente to Point Dume. Operators of the gambling ships remained defiant, so Warren ordered officers to raid the ships and arrest the personnel aboard them. The *Rex* was the last to surrender, holding officers at bay for eight days by spraying water at intruding law enforcement boats using the ship's high-powered fire hoses. The standoff at the time was referred to as "The Battle of Santa Monica Bay." Finally, on August 10, 1939, Cornero surrendered, telling the press "I needed a haircut." Months later, officials boarded the ship and destroyed all of its gaming equipment. In the process they discovered that most of the machines had been rigged. The patrons of the *S.S. Rex* never had a sporting chance.

From top left: A five-dollar gambling chip from the S.S. Rex; a matchbook advertising directions to get to the ship; water taxis approaching the infamous gambling barge; a full-page advertisement placed in a 1938 issue of the Los Angeles Times.

Opposite: Patrons return to the Municipal Pier aboard one of the water taxis that serviced the S.S. Rex.

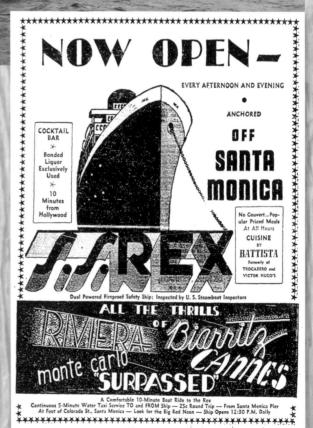

Santa Monica Pier

The West End

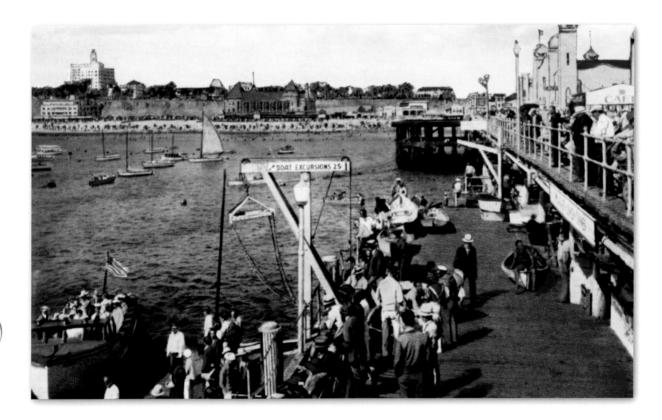

eople seem to have a need to go as far as they can to break the barriers established by Mother Nature. The west end of the pier fulfills that need, providing the power that people unconsciously seek. Home to the fishing community, fondly remembered by the boating community, and tempted by the fury of the sea, the end of the pier has had a colorful life of its own. It grew beyond being an "end." Rather, it is a way for visitors to connect more closely with the sea.

Beginning on opening day in 1909, ships from the United States naval fleet regularly anchored a short distance from the end of the pier. The first such ships were of the cruiser and battleship classes—the *U.S.S. Albany*, the *U.S.S. Arizona* and several others stopped by Santa Monica for a little rest and relaxation.

rental. I worked at that place, too. As a matter of fact, I quit school to work there.

That's how much I liked this pier-I even quit school for it."

—John "Yosh" Volaski, co-owner of Santa Monica Pier Bait & Tackle Shop, 2007

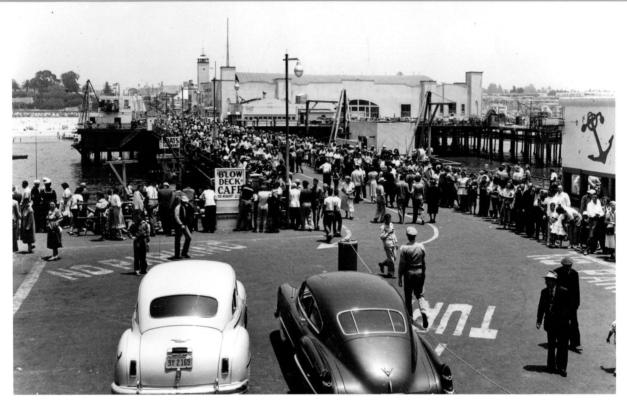

In later years, aircraft carriers such as the *U.S.S. Saratoga* and the *U.S.S Lexington* visited, the huge ships silhouetted against the horizon stealing the breath away from hundreds of onlookers. Sailors came ashore and water taxis carried civilians who toured the ships.

When the long-anticipated Santa Monica Yacht Harbor became a reality, the west end drew even more attention. In 1934 the City extended and expanded it, adding a second level below the west and north sides of the pier, suspended approximately eight feet above the water. Offices for the harbormaster were constructed on the southwest corner of the upper level in 1934 and the previously existing Standard Oil gasoline facilities were moved to the lower deck for better access. Finally, three inches of asphalt were laid over the upper level decking. By 1937 the rest of the Municipal Pier and the Pleasure Pier were covered with asphalt as well.

The lower level cultivated a thriving life of its own. The lifeguards kept quarters on the far west side, and lifeguard legend Pete Peterson set up a workshop there and built his own dories, paddleboards and rescue tubes. In the 1960s the Standard Oil station vacated the lower deck, and in 1965 the Oatman Rock Shop took over the space. Other businesses that occupied the lower deck were the Port Hole Café and the Below Deck Café.

This 1949 photograph shows the west end of the Pier during the height of its popularity. Fishing and boating were but two of the attractions. Driving a car out onto the west end was a special family treat.

Opposite: The lower deck of the west end took on a life of its own with boating operations including sportfishing excursions, harbor tours, and even rowboat rentals.

Countless storms have unleashed their fury on the west end, boats have slammed into its pilings, and debris from less fortunate piers have battered it, yet through decades it stood its ground. Perhaps the most frightening event in its history had little to do with the ocean at all. In the summer of 1945 the twenty-eight-foot fishing boat Nadine, recently put into the water after an overhaul, filled up her fuel tank with 250 gallons of gasoline at the Standard Oil station. As her captain, Bert Taylor, turned on the boat's ignition, a spark ignited gasoline that had spilled onto the deck. The boat's fuel tank exploded, blowing the hatch of the boat two hundred feet straight up into the air as the rest of the boat became engulfed in flames. Taylor miraculously escaped with only minor burns. Quick action by the lifeguards, Santa Monica Fire Department and U.S. Coast Guard kept the fire from spreading onto the pier and igniting the Standard Oil station.

In 1948 a water taxi for the fishing barge Trade Winds was found slowly sinking about a

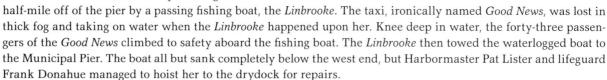

Such commotions did not spoil matters for the fishing community. Everything else around the fishermen—the boating, the cafés, the stores—was fine as long as there was still space to drop a line in the water to reel in a mackerel. Only once in the last half of the twentieth century was that public fishing space in jeopardy. In 1965 the South Coast Corinthian Yacht Club, having tried for decades to secure a private clubhouse on the pier, sought to lease a significant amount of the lower deck, one of the most popular fishing spots on the entire west end. The City liked the idea of receiving rental income, but fisherwoman-turned-activist Diana Cherman organized a protest and, along with a school of fishermen, protested to the council members. Cherman insisted that there was more at stake than money. The pier was for all people—"a public pier," she insisted, adding that money should never dictate who uses a public pier. The scrappy little bunch prevailed, and the fishing spot was saved.

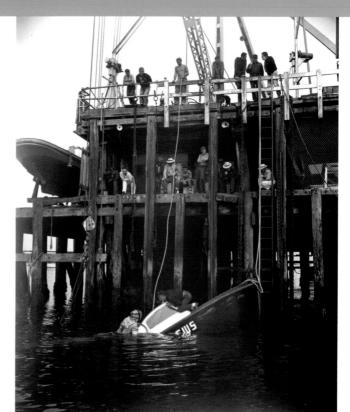

Opposite: A group of schoolchildren on tour of the Pier is greeted on the west end by a member of the Harbor Department in 1950.

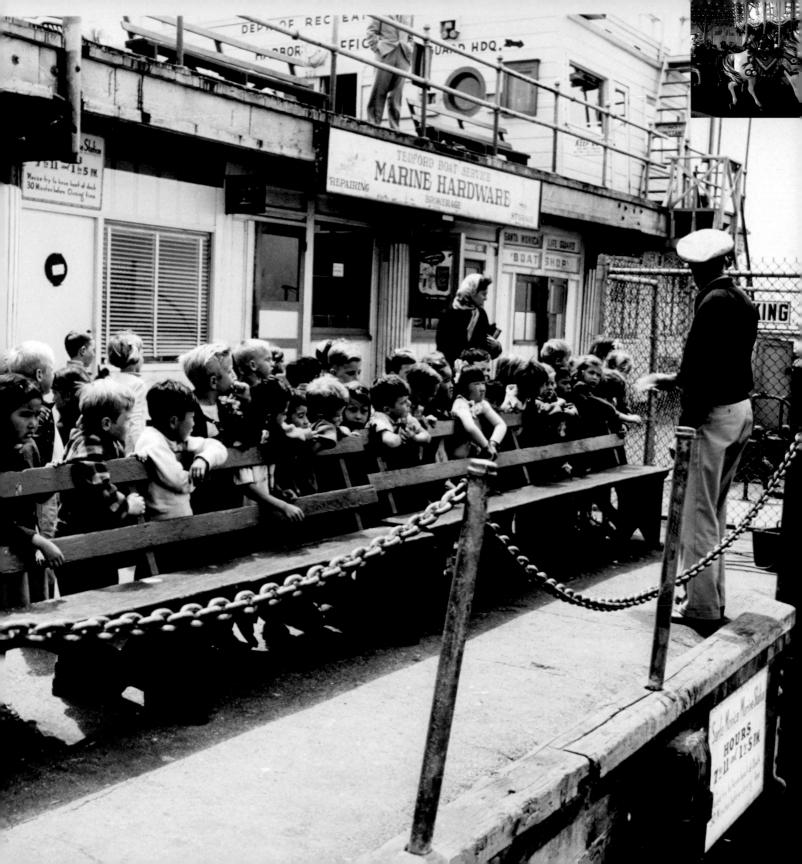

THE EYES & EARS OF THE PIER

ifeguards first appeared in the mid-1920s as an informal group of volunteers dedicated to rescuing distressed ocean bathers. By the late 1920s they became an official summertime service at Santa Monica Beach under the supervision of Knute Knudsen and George Watkins. A few years later, the Santa Monica Lifeguard Service, under Captain Watkins, became a year-round operation. In need of a headquarters, the lifeguard service established offices in the pier's Bowling & Billiards Building in 1932. In 1935 the guards relocated to the La Monica Ballroom.

The lifeguards' athletic abilities attracted Hollywood, and several of them found work in the film industry. The attraction was reciprocal; actors/Olympians Buster Crabbe and Johnny Weissmuller were initiated as honorary lifeguards. Weissmuller even nabbed headlines in a couple of ocean rescues—in 1933, he leaped off the pier to save a swimmer from drowning, and, in 1943, he made a beach rescue about one hundred yards north of the pier.

Renowned for rescue and safety abilities, the lifeguards contributed to the community in many capacities. When the yacht harbor opened in 1934, Captain Watkins and his guards were called upon to establish rules and regulations to keep the harbor safe. During World War II guards dove for abalone and lobsters, donating their catch to the community to ease local food shortages.

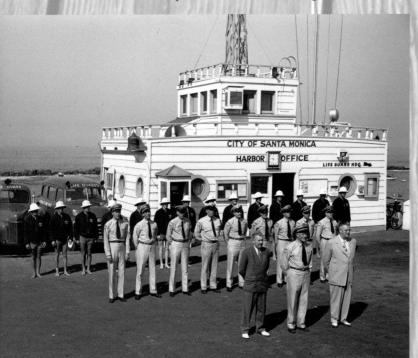

A few years after the war ended, the City of Santa Monica relinquished its control of the lifeguards and turned the service over to the supervision of Los Angeles County. The guards maintained their chief presence on the pier until 1958 when a new beach-level headquarters was built a few yards to the south.

The Santa Monica Harbor Patrol has since assumed that twenty-four-hour presence on the pier, providing first-response to area emergencies and first-aid. The Harbor Patrol also maintains the pier's pilings and supervises activity near the remains of the breakwater.

The Santa Monica Harbor Department and the Santa Monica Lifeguards line up for this publicity photo, in the 1940s.

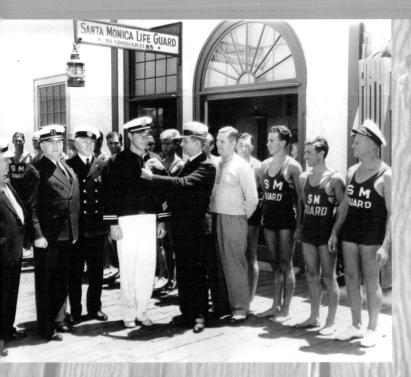

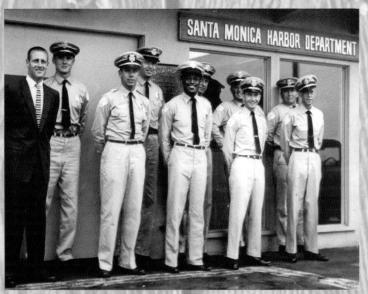

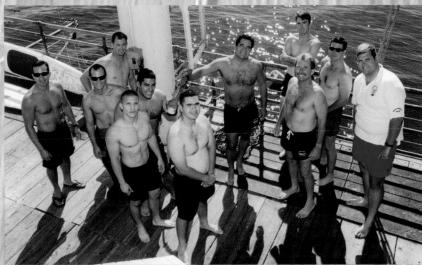

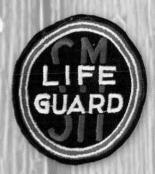

Clockwise from top left: Olympian/actor Buster Crabbe receives his commendation as an honorary Santa Monica Lifeguard in the early 1930s; the 1962 Harbor Department (left to right: Tom Volk, Warren Rigby, Barrel Lotti, James Craig, William Harkley, Walters Reeves, James Eckert, Chad Merrall and Fitz Williams); an official 1974 lifeguard patch; the 1998 Harbor Patrol (left to right: Abby Balderas, Luca Gaetani, Matt Anderson, John Hatfield, Mike Ortiz, Edgar Navarro, Pete Breceda, Dave Finley, Wayne Salkoski, Dan Buchanan and Tom Brierley)

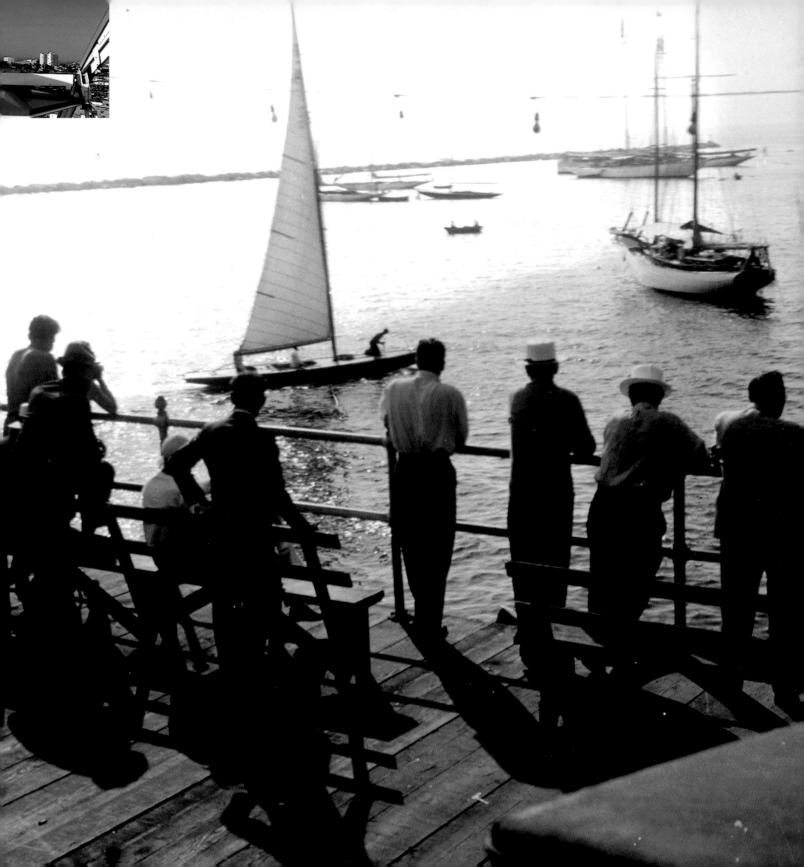

55

Keeping the Harbor Afloat

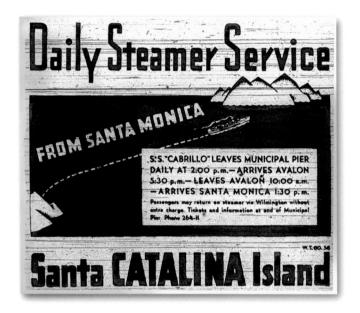

anta Monica Yacht Harbor was extraordinarily popular in its early years. No sooner was it complete than motion picture star Charlie Chaplin moored his yacht *Panacea* (although rather than use his own name, he registered it under the name of his soon-to-be bride Paulette Goddard). By the end of August, the harbor already boasted ninety-nine yacht moorings. Sailboats were a regular sight in the protective calm provided by the new breakwater, and many beach bathers found the water less of a challenge on the north side of the Municipal Pier since the breakwater controlled the waves.

The harbor also had a big impact on its surroundings. New restaurants such as O.J. Bennett's Seafood Grotto and The Galley thrived as a result of its presence. Likewise, shops for boat rentals, repair, parts and maintenance cropped up on the pier deck. The environment changed as well. The presence of the breakwater affected the ocean's natural current and the beach accumulated sand at an alarming rate, expanding the north beach to more than three times its normal width.

"People on the pier get infected by it and eventually they become the pier. They have saltwater in their blood and deck boards in their bones."

-Pete Breceda, retired Harbor Patrol guard, May 14, 2008

In the summer of 1935 the steam-ship *Cabrillo* offered daily service to Santa Catalina Island, much to the dismay of many yachtsmen, who felt that the large ship's path through the harbor would take up too much valuable mooring space. As if answering the yachting community's prayers, heavy swells often prevented the *Cabrillo* from accessing the harbor. Ultimately interest in the Catalina service faded, and operations shut down altogether the following August, though they resumed briefly aboard the ship *Narconian III* in the late 1930s.

With the outbreak of the Second World War came the virtual end of the harbor's relationship with the yachting community. United States naval activities displaced entire fleets of fishing boats moored in Los Angeles, Newport, and San Diego harbors, forcing them to relocate to smaller harbors. By December 15, 1941, forty-six of these boats found a home in Santa Monica and embarked

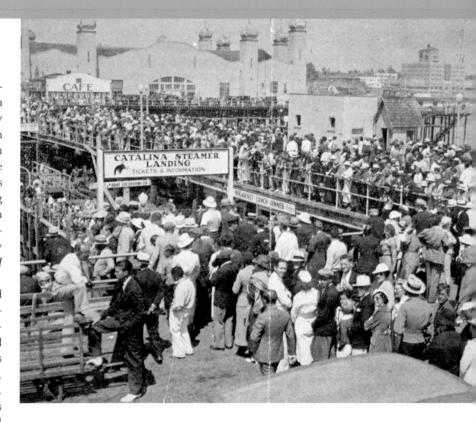

upon a very successful business. Tons of mackerel were hauled in daily, unloaded at the Municipal Pier onto cargo trucks, and shipped out to canneries in San Pedro. As luck would have it, business became too good. The pier deck and substructure took a substantial beating from the large trucks. In September 1942 city officials lowered the legal vehicle-weight limit from five tons to three tons, a crippling blow to the fishing industry. The inability to ship their haul from the pier forced many boats to dump their day's catch into the bay rather than let it rot in their boats. In early October 1942 as much as ten thousand tons of dead mackerel littered the harbor waters. The United States Department of War intervened and ordered emergency repairs to be made to accommodate the trucks and resume operations.

The yachting community, for whom the harbor was built, was overlooked in the fishing rush. Years of storms had damaged the breakwater enough that the harbor's waters were no longer optimal for mooring, and the City was slow to begin repairs. Yacht owners began to depart for more amenable anchorage.

At the end of the war the status of the breakwater drew significant attention. Los Angeles officials made a formal plea to have the breakwater removed because of its negative erosion effects on southern beaches, a call which infuriated Santa Monica officials. Commissioners D.C. Freeman and W.W. Milliken pointed out that the

56

When it was first offered, the Catalina service was immensely popular. In time, however, interest faded and the service was discontinued. Opposite, top: Errol Flynn anchored his yacht in the harbor in 1946 while he gathered supplies and enlisted crew for a tropical cruise. Bottom: Yachts of all shapes and sizes decorated the much anticipated harbor in 1934.

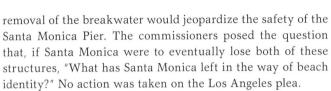

By the late 1940s the majority of boats that braved the harbor's increasingly choppy waters were fishing boats. Efforts to regain the interest of the yachting community were unsuccessful. While a few yachts did remain, even they moved on over time. Ongoing dredging and repair costs became a financial drain on the City, and by the early 1980s little was left of the breakwater and Santa Monica Yacht Harbor.

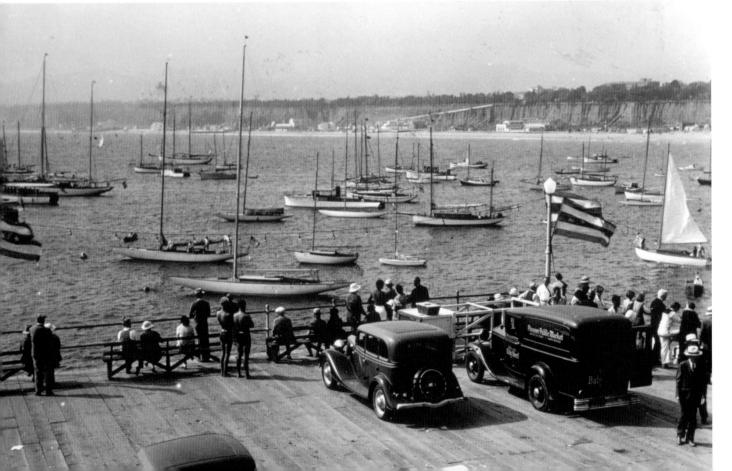

TOP TEN THINGS THAT STARTED

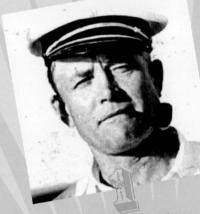

"Born in a typhoon off Santa Monica,"
the famous sailor man was modeled after
the famous fishing boat operators,
one of the Pier's fishing boat operators,
Captain Olaf Olsen. (1929)

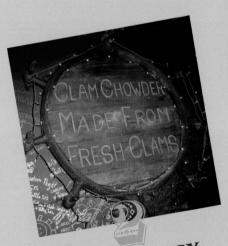

THE GALLEY

Santa Monica's oldest restaurant

was located on the Pier for twelve years

before moving to its current

Main Street location. (1934)

"CHEZ JAY"
Santa Monica's most famous restaurateur,
the late Jay Fiondella cut his teeth as
a bartender at Sinbad's. (1956)

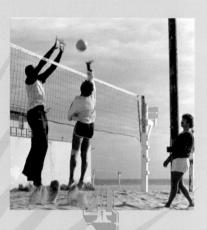

VOLLEYBALL
The first doubles tournament,
so popular today, took place at the courts
immediately south of the Pier. (1930)

BEACH

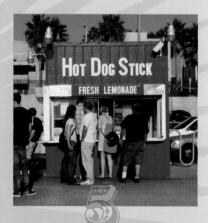

HOT DOG ON A STICK

Dave Barham's little red hot dog stand south of the Pier has become an iconic franchise. (1946)

AT SANTA MONICA PIER

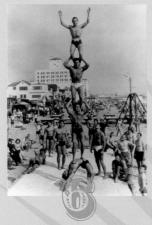

MUSCLE BEACH

Providing free entertainment during a time when money was scarce, Muscle Beach went on to become the birth of the fitness revolution. (1930s)

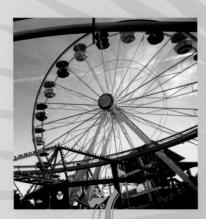

SOLAR POWERED **FERRIS WHEEL**

The sun makes it go around and around and around. (1998)

LIVE TV BROADCAST OF VARIETY SHOW

KTLA's Hoffman's Hayride featuring country-swing legend Spade Cooley was the first to broadcast live. (1948)

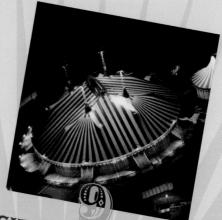

CIRQUE DU SOLEIL U.S. TOUR LOCATION

Now seen in locations throughout the world, the stop that started it all was in the parking lot just north of the Pier. (1988)

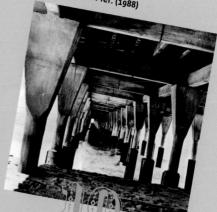

CONCRETE PILES

They gave the Pier its original notoriety, and though they lasted only ten years, they paved the way for technological advances on the West Coast. (1909)

Expansion and Contention

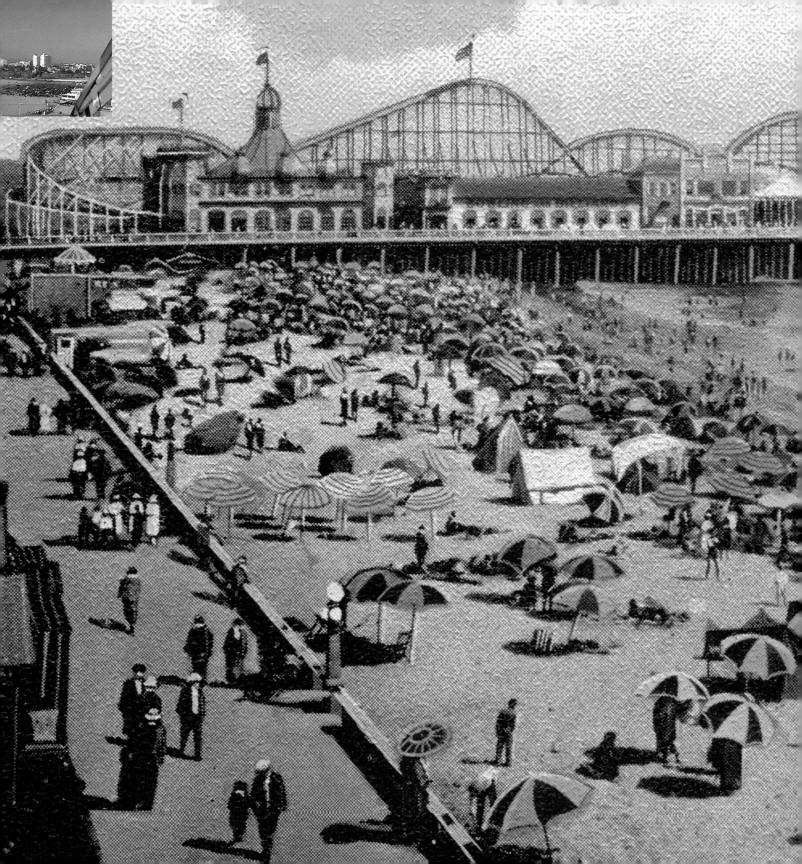

The Last Great Pleasure Pier

Save the Pier!

A
Friend of
the Pier is
a Friend of
Mine

SAVE SANTA MONICA PIER

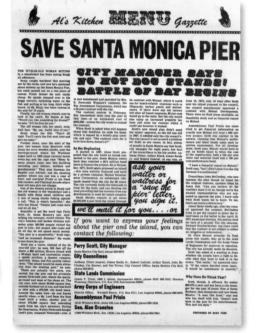

IST ANNUAL
PIER APPRECIATION DAY
FISHING DERBY
APRIL 5TH
SAVE THE PIER
CITIZEN'S COMM.

or nearly sixty-four years nobody dreamed it could happen. The notion that the City would tear down Santa Monica Pier, a structure that it owned and that offered free pleasure to its citizens, had never really entered anyone's mind. Furthermore, it was the last of the famous pleasure piers that once lined the Southern California coast. If anything, it was a monument. Nobody would be crazy enough to tear down a monument. But there it was in the newspapers, there it was on the television, and there it was on the Santa Monica City Council dais: The pier, the heart of Santa Monica, was going to be torn down.

To the City Council members the idea seemed sound enough. The Municipal Pier and breakwater had been a financial drain for years, and each was in a state of such disrepair that the cost of salvage and restoration was becoming increasingly unrealistic. Furthermore, the Newcomb Pier's lease was set to expire in 1973, and pro-

Message buttons were one of the most popular fashion accessories to communicate a political point in the Save the Pier campaign of the early 1970s. Center: The menu at Al's Kitchen was adapted as a brochure to enlighten customers about the City Council's decision to raze the Pier.
Opposite: Concerned citizens gather at City Hall to protest the 1973 decision to tear down the Santa Monica Pier.
Opening spread: The Carousel, Whirlwind Dipper and La Monica Ballroom defined the pier's profile in 1924.

O: MEMBERS SANTA MONICA CITY COUNCIL

RE: "SAVE THE PIER"

ON BEHALF OF THE MILLIONS OF PERSONS WHO HAVE ENJOYED THE RECREATIONAL BENEFITS OF THE SANTA MONICA PIER AND THE NEWCOMB PIER, WE RESPECTFULLY URGE THIS COUNCIL TO RESCIND ITS VOTES TO DEMOLISH THE PIER.

NAME	ADDRESS	CITY
2 Al	10050 Blamontone	Saffermalical
Farre Pode	1205 & Brown fave	San Parameter Co
Marguerite Chasters	7151 alway by #c	L. B. Ener 9004
the fire concelle.	4063 EILEEN ST	Sin Valla
Dant Lotstein	421 mose ST.	Burbankel
Typic 100 D/ J	11260 Messonilve 2	Los Angeles
Chiel Voin	11260 Missonei (fire #)	11/1
Dusun K Patt	928 215T Street # 3	Sul Mon
hachel tompasen	360 n. Berendo III	Ra Clowy ton
Sefert a Compayel	1047 GW. Washington Ble	1 F Tenice
" Level he Sehan	111740 Wilshin Blid	6.4 90021
+ palsan	Tacific Chast Highway	
Tharon Hass	9308 Lloydorest A Ben He	
Die Spri Frank	259 W. Channel Rd	S. Monica
noque Braning ag	949 Ne. Dokeny De	Burg Hell
Mary Street	Universal Deroles	universel
+ Markice To 82		
Siz Roughide	thineral Etudios	Universal Wit
Id Domeis	Box 8446 Universel at, 916	
Donath, Brutte	10055 Bearly and	auta (Mpas

HEADQUARTERS --- 370 Santa Monica Pier

Turn the petitions into our headquarters no later than February 9th

visions in the lease called for demolition within six months of expiration.

Major changes to the harbor had been discussed as early as 1963, when hopes to convert the breakwater into a causeway connecting Santa Monica to Malibu surfaced and received considerable local support. Plans for the causeway ultimately fell through, and in 1971 the City Council turned to City Manager Perry Scott to come up with a solution to improve the pier and harbor area. Scott returned to the council in November 1971 with a proposal for a thirty-five-acre island featuring a high-rise hotel, a convention center, restaurants and several other amenities. What Scott's plan did not include was the pier. He proposed that the pier be torn down in favor of a four-lane bridge which would provide access to and from the island. On June 13, 1972 the City Council unanimously approved of the project.

The public reacted immediately. Citizens of Santa Monica and West

Los Angeles formed Save the Santa Monica Bay, a campaign endorsed by local environmental groups including the Sierra Club, and rallied enough support to assure that the project would not receive the required state and national approvals necessary to proceed. By the following December the City Council began to suspect that the island, like the causeway a decade earlier, might be a futile pursuit. At their January 9, 1973 meeting the council was confronted by more than two hundred people who assembled to protest the island. Recognizing the need for further discussion, as well as the need for a larger forum, the council scheduled an "Ocean Front Revitalization" public hearing at the Santa Monica Civic Auditorium on January 23.

One thousand people filled the auditorium to protest the island that night, voices that carried the meeting until well after midnight. The council heeded their protest, and voted to disapprove the island project. As the jubilant crowd left the building commending one another on their success, a murmur began to emanate from those who had remained in the chambers. The rumbling sound became clearer as it reached the people outside the auditorium,

escalating finally to the cries of "They're going to tear down the pier!" Only minutes after the defeat of the island project, while most public ears had turned away from the dais, the council abruptly passed a motion to destroy both the Municipal and Newcomb Piers.

The stunned community immediately took action. Two citizens' groups, Friends of the Santa Monica Pier and the Save Santa Monica Pier Citizens' Committee, promptly formed and set forth to sway public opinion against destroying the pier. Each group embarked upon ground-level publicity campaigns, circulating fliers, buttons, t-shirts and bumper stickers and soliciting support from Los Angeles media to bring greater attention to the im-

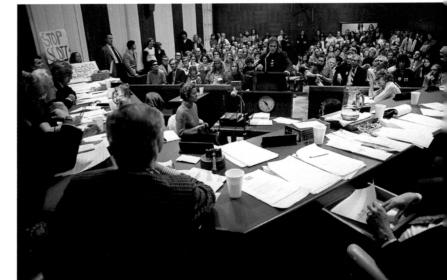

Santa Monica Pier

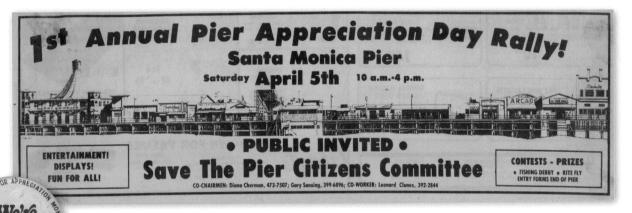

pending loss of the beloved pier. Friends of the Santa Monica Pier was a group of local artists and activists which based its operations in the small café Al's Kitchen. The committee was chaired by cook Larry Barber and financed by owner Joan Crowne, but the mastermind behind it all was café manager Jack Sikking. According to Barber, "Sikking had the idea and the vision for what we might be able to do. He was a great resource with creative ideas." As the campaign gained momentum, Sikking developed a propos-

al to make the pier more economically viable and attractive. The Save Santa Monica Pier Citizens' Committee, co-chaired by Diana Cherman, Gary Sansing and Leonard Clunes, congregated in the Sinbad's building. They worked closely with pier merchants and circulated a petition to save the pier. Signatures accumulated rapidly and easily.

When the City Council met again on February 13, they were again greeted by a passionate mob. An estimated 350 people filled the chambers and overflowed into the hallway; the chant "Save the Pier" echoed throughout the building. Councilman John McCloskey, who had previously voted against demolishing the piers, proposed a motion to rescind the council's decision; the motion was tabled. Members of the public demanded a public hearing; they were denied. Diana Cherman approached the dais with a thick stack of petitions signed by over ten thousand people; it was rejected. The public's frustration festered as each attempt to discuss saving the pier was rejected, and the room grew hot and uncomfortable. Sensing that emotions were about to erupt, Mayor Anthony Dituri appeased the crowd by allowing *Friends of the Santa Monica Pier* chair Larry Barber to speak. The crowd hushed as Barber detailed Jack Sikking's inspired plan to restore and revitalize the pier. The council and the audience were invited to visualize a completely renovated carousel, a museum, an art gallery, a theatre, upscale restaurants and a park. "The pier is a place of magic," Barber said, "It's a place to renew myself. That's why we come here with a plan not for urban renewal, but for human renewal." The presentation provided a glimpse of hope on an otherwise disheartening night, yet it did nothing to sway the council's decision. The meeting ended as it had begun; the pier's fate remained the same.

Undeterred, the campaign to save the pier shifted to another gear. Three City Council seats were up for

65

The Last Great Pleasure Pier

re-election, and the incumbents who occupied those seats, Robert Gabriel, Arthur Rinck and James Reidy, Jr., became public targets for their failure to support the pier. A massive campaign was begun to support candidates who wished to save the pier, and the three incumbents soon took notice. By the end of February, Gabriel, Rinck and Reidy each announced that they had changed their stance about the demolition of the pier. At the next council meeting, February 27, 1973, the council voted unanimously to rescind the order to demolish the Municipal Pier. The council took no action in regard to the Newcomb Pier, however. Since the Newcomb lease was expired, the order to raze it by November 1 still stood. The council then proposed the formation of a Citizens' Committee that would research and make recommendations for the best use of the beachfront and the pier.

The community was not satisfied. The Newcomb Pier was considered a vital and precious part of the pier as a whole. The Santa Monica Pier Businessmen's Association, though less visible in the early months of the Save the Pier campaign, emerged as the election came closer. Their slogan "Don't Disap-Pier" focused

on making certain that the *whole* pier survived. The best way to ensure this was to continue with the plan to have Gabriel, Rinck and Reidy removed from office.

The election of 1973 became a political turning point for Santa Monica. Long controlled by the wealthier community of businessmen and homeowners, the hotbed created by the Save the Pier movements initiated a youth movement in voter registration. As the polls closed on April 10, Gabriel, Rinck, and Reidy felt confident that they had been reelected. To their surprise, they were replaced by Fred Judson, Donna Swink, and Pieter van den Steenhoven.

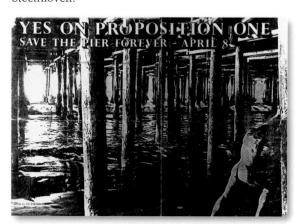

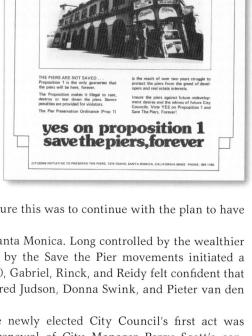

By the Citizens of Santa Monica

The newly elected City Council's first act was to decline renewal of City Manager Perry Scott's contract. The council then voted on May 8, 1973, to save the Newcomb Pier from its scheduled demolition. Then, after over a year of proposals, negotiations and legal filings, the City Council negotiated the purchase of the amusement pier from Mrs. Newcomb-Winslow on June 28, 1974, bringing ownership of both the Newcomb and Municipal Piers to the City of Santa Monica.

To assure that the pier would never again be threatened by elected officials or any other interests, the "Citizens Initiative to Preserve the Piers" introduced Proposition 1, an initiative to preserve both the Municipal

and (formerly) Newcomb Piers forever. The initiative passed by almost two-thirds of the vote on April 8, 1975. The Santa Monica Pier was not only saved, it was assured permanence. That year also saw the creation of the Santa Monica Landmarks Commission, initiated in part as a result of the Save the Pier campaign. On August 17, 1976, the Landmarks Commission honored the pier by declaring it an official historical landmark of the City of Santa Monica.

The pier still needed work—lots of it. Structural rehabilitation and business redevelopment were imperative if the pier was going to remain standing and become a viable contributor to the City. Caught up in the wave of optimism, numerous proposals for revitalizing the pier were introduced; a new amusement zone adjacent to the carousel was explored, restaurant entrepreneur Bob Morris presented plans to place his restaurant Gladstone's 4 Fish on the existing Fisherman's Wharf, and another group hoped to open a dance club inside the Bowling & Billiards Building. As the 1970s passed into the 1980s, however, each of these dreams faded away. In the fall of 1981 the City of Santa Monica created the Pier Task Force, a committee of people whose interests and talents were pooled to determine the development direction of the pier. The committee held a series of public meetings and workshops in order to gather public input to help determine their own recommendations. The pier's future now appropriately rested with the very people who had fought so strongly to save it.

Even the horses on the merry-go-round were grateful that the Pier was saved; their message of gratitude is above the Carousel Building's entrance. Opposite: In 1975 the people of Santa Monica voted on Proposition 1, an initiative that would preserve the Pier forever, and it passed with nearly two-thirds of the electorate in support.

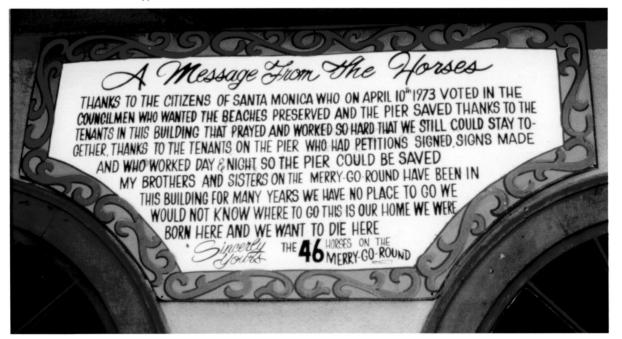

MOVIE STARDOM & TV FAVORITES

ver since the advent of the motion picture industry in the early 1900s, the pier has been a regular sight on the big screen, securing its renown as the "World Famous Santa Monica Pier." Its relationship with the movie industry is unique. At times it has stretched beyond the camera/set dynamic into something even more interactive. Well-known actors have become trained as lifeguards, starting with Johnny Mack Brown, and including two famous Olympic-stars-turned-screen-performers Buster Crabbe and Johnny Weissmuller. Weissmuller made headlines twice for performing rescues from the pier. An entire fleet of fully rigged sailing ships was moored in the yacht harbor for a short period in 1939 solely for use in Hollywood movies. The harbor became a venue for companies to develop techniques in

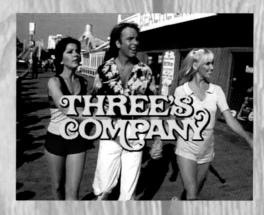

underwater photography, and the lifeguards' aquarium shared a similar role with film companies who attempted to train ocean wildlife for the camera.

Among the multitudes of television shows which have had memorable moments on the pier are favorites such as Charlie's Angels, TJ Hooker, Three's Company, 24, Ugly Betty, CHiPs, Simon & Simon, and Baywatch.

Movies tend to spend a considerable amount of time and attention on the pier's detail. Some which have

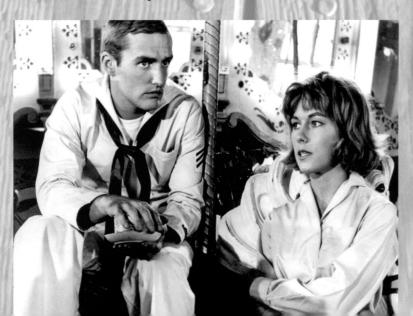

done an especially thorough job include 1965's *Inside Daisy Clover*, which shows extraordinary footage of the Newcomb Pier; 1961's *Night Tide*, in which Dennis Hopper takes the audience on a fantastic tour of the Carousel Building's apartments; and 2004's *Cellular* which was shot extensively both on the pier and amid the pilings below deck. A short list of films shot at the pier includes:

A Society Sensation 1918, The Lost Squadron 1932, Fallen Angel 1945, Pitfall 1948, Quicksand 1950, The Glenn Miller Story 1953, Elmer Gantry 1960, Funny Girl 1968, They Shoot

69

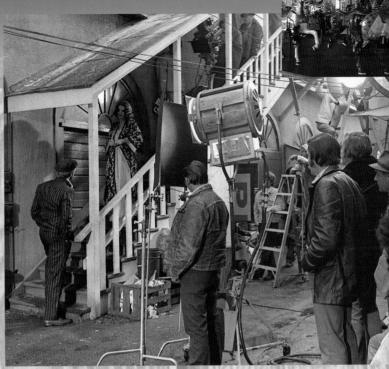

Horses, Don't They? 1969, The Sting 1973, Ruthless People 1986, Forrest Gump 1994, The Net 1995, The Majestic 2001, Cellular 2004, Fat Albert 2004, Bedtime Stories 2008.

The earliest of these, A Society Sensation, was a silent film starring the famous ladies' man Rudolph Valentino opposite actress Carmel Myers. One scene, shot under the pier, called for Myers to be in the water, fully dressed and in need of rescuing. Director Paul Power repeatedly yelled for Valentino to jump in and save her—the scripted action in the scene. Valentino continually ignored the order. Finally, after holding up production for quite some time, Valentino jumped into the water to satisfy the director. At that moment, just after he had done his director's bidding, it was revealed that Valentino couldn't swim. He sank, and had to be rescued.

The movie most associated with the pier is the 1973 classic, *The Sting*. Fittingly, the stories surrounding this classic film are now firmly part of the pier's proud lore. The movie was filmed during the tumultuous period when the pier was under the threat of being torn down. While people outside the movie set were working hard to save the pier, the film crew and its stars, Robert Redford and Paul Newman, were concentrating on creating the atmosphere of Depression-era Chicago. Desperately in need of a break in the tension, each of the famous actors eagerly complied.

Jay Kennedy, an off-duty Los Angeles police officer working security for the film, recalls light-hearted moments with each of the film's famous stars. While Newman was preparing for a scene shot inside the carousel building, he spotted Kennedy eating fish and chips. Just as director George Roy Hill called "Action!," Newman grabbed a handful of the security guard's lunch, shoved it into his mouth, and turned toward the camera with a mouthful of food, forcing Hill to stop shooting. Hill gave Newman a few minutes to finish chewing, then, just as they were ready to start filming again, Newman put another handful of food in his mouth and turned to the camera again—

-Larry Pearson, location manager for Fox-TV's Stand Off

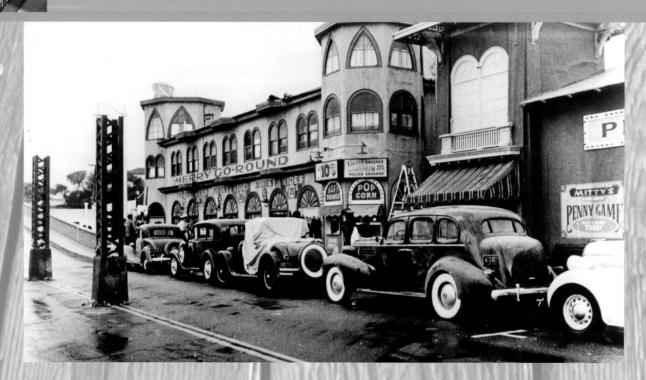

mouth full and unable to do his lines. As for Redford, he enjoyed throwing a football. "He'd finish shooting a scene," Kennedy recalls, "come nudge me with the ball and we'd go off and play catch. That's all he wanted to do!"

The threat of losing the Santa Monica Pier did not escape the two high-profile actors' attention. Both Redford and Newman, each known to be press-shy, took time to pose for photos and share their feelings of support

for saving the pier. The Santa Monicaborn and raised Redford, in an interview with the Los Angeles Times, stated "The pier is a landmark. Everybody likes to visit the pier. I think it should be made into a museum. Not just out of nostalgia, but for a sense of history." Both men even signed the petition to save the pier.

Top: Classic cars line up in front of the Carousel and Bowling & Billiards buildings to help dress the set as 1930s Chicago for *The Sting*.

Bottom: Robert Redford holds a football between takes for *The Sting*. He enjoyed throwing passes when not on the set.

Opposite: Redford's character, Johnny Hooker, walks alongside the merry-go-round.

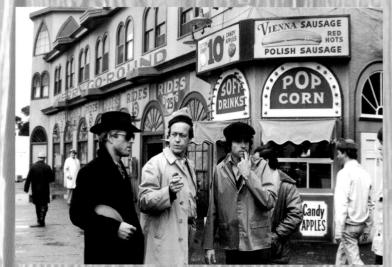

70

Santa Monica Pier

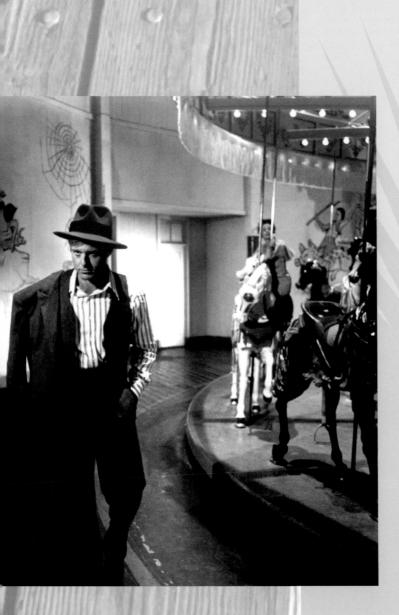

CELEBRITY SIGHTINGS

ince so many movies and television shows are shot at the Pier, celebrity sightings are almost as regular as sunglasses and swimwear. Some notables, however, have been noticed frequenting the Pier even in their off-time:

- Singer/songwriter Stevie Wonder held his granddaughter's birthday parties at the Carousel throughout her childhood.
- Actor Don Cheadle often strolled the deck with his daughters on early weekend mornings.
- Hannah Montana stars Miley Cyrus and Emily Osment both list the Pier as a favorite place to hang out.
- In 1935 Joan Crawford made headlines by kissing actor and soon-to-be husband Franchot Tone upon her arrival via speedboat from Catalina Island. (Years later her adopted son Christopher made headlines when he ran away from home and was found hiding out at the Pier.)
- Director James Cameron and actress Linda Hamilton regularly enjoyed sunset dinners at the Boathouse restaurant during the late 1990s.
- Actor Leo Carrillo ("Pancho" from TV's The Cisco Kid) was one of the Pier's most regular visitors. A known yachtsman and close friend to the fishing community, he was often called upon to serve as master of ceremonies for events at the Pier.
- United States Congressman Dennis Kucinich and his wife, Englishwoman Elizabeth Harper, consider the Carousel one of the their favorite places in the world.
- Hall of Fame basketball player Wilt Chamberlain regularly played volleyball on the beach courts immediately south of the Pier.
- Actor Mark "Luke Skywalker" Hamill frequently enjoyed listening to local bands play at Rusty's Surf Ranch.

The Storms of 1983

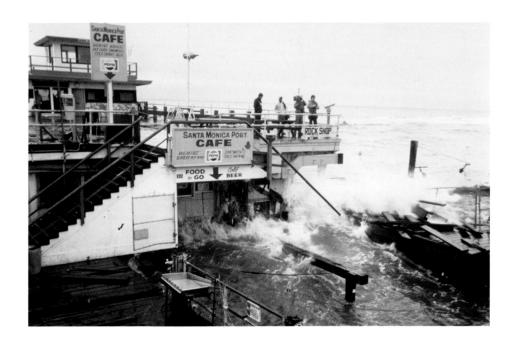

or nearly three-quarters of a century, the pier stood fast against any attempts to dismantle it. When its original concrete piles succumbed to the erosive power of nature, the pier persevered; its pilings replaced while the deck still hovered above the sea. Storms raged, then passed, but the pier carried on. When progress threatened to cast it aside, the people stood by it and assured it infinite life. In the early months of 1983, just under a decade after being preserved by the people, the pier's resilience finally failed. Neptune, so long defeated by the sturdy pier, finally had his revenge.

The volatile storm season was no surprise to Santa Monicans; in fact, many thought the area was due—the "Hundred Years' Storm," some called it. Scientists predicted that the warm waters associated with the *El Niño* phenomenon would profoundly affect the winter of 1982-83. But no one anticipated the power of *El Niño*'s storms.

Waves crashes over the west end's lower deck as a camera crew documents the January 27, 1983 storm. Opposite, top: The lower deck begins to crumble.

"During the storm in 1983 people were talking about a white truck that fell in the ocean, and we felt sorry for the person, then we saw it and realized, 'That's our truck!'"
—Sheila Ostrow, former Pier business owner, 2008

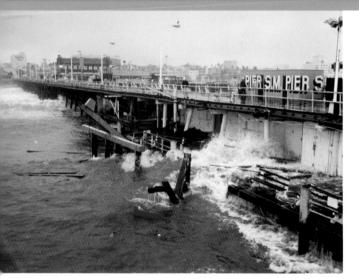

During the last week of January, Southern California was battered by four of them.

On the morning of January 27, 1983, the third and most powerful storm struck the pier. Swells were predicted to reach ten feet and, since the lower fishing deck of the pier stood only about eight feet above the water, some part of the pier inevitably was going to give way. The news of the impending drama spread quickly. Crowds braved a brutal and driving rain as they lined up along the cliffs of Palisades Park to witness nature's fury. Shortly after dawn, waves broke over the top of the fishing deck and, within less than two hours, most of the lower deck washed away. The northwest corner separated from the rest of the pier, stood solitarily for a moment, and then plunged into the water.

The lifeguard station was the first victim, followed by the Oatman Rock Shop, the Port Hole Café and the boat lockers. Maintenance workers who had been observing the storm from the precarious west end realized that they were in danger and hurried toward safety at the shore end. The Santa Monica Police Department barred access to the entire west end. By 9:30 a.m. the Harbormaster's Office, too, was lost. Only Santa Monica Sportfishing and the lifeguard boat *Santa C* remained atop the west end deck.

As the storm subsided, people flocked to the beach south of the pier to collect souvenirs—pieces of the pier washed ashore, littering the area with shards, splinters and entire sections of the once-proud wooden structure. Others stood silently, observing the wreckage in solemn despair. With another storm approaching, the City closed the pier and the beach until public safety could be assured.

City engineers surveyed the damage and determined that the pier was not as severely damaged as early indications had led them to believe. It hardly mattered what they said, however—there was little argument as to whether or not the pier would be saved. "The overwhelming sense of the community is to fully restore the pier," City Manager John Alschuler told the Los Angeles Times.

Reconstruction commenced within a couple of weeks. A thirty-ton crane was brought onto the pier to begin the process of demolishing the dangerous remains of the lower deck.

The harsh *El Niño* season was not over yet, though. A new, more powerful storm teamed up with the year's highest tides to take advantage of the reeling pier. Upon hearing weather reports issued by the United States Coast Guard, the City's Pier Maintenance officials warned the construction crew that the crane needed to be moved to a more stable part of the pier. The crew moved the crane about fifty feet shoreward, but with the workday ending soon and the hard rains increasing, the crew stopped and pronounced it safe

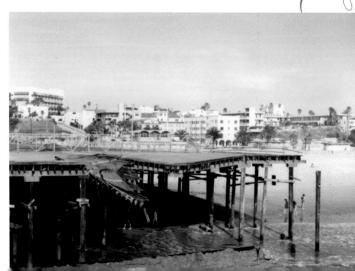

73

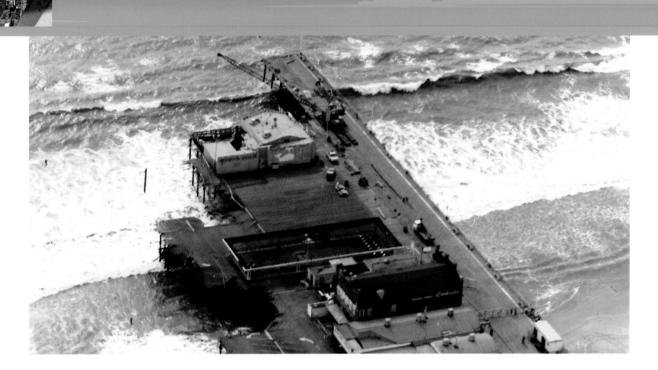

at its new location. At about 8:30 p.m. on March 1, 1983, the pier began to sway with the powerful surf. Sections fell off the west end and, as midnight approached, the pilings underneath the heavy crane collapsed, sending the crane tumbling into the sea. The crane began knocking over the pilings within its immediate vicinity while the large timbers that had supported it drifted into the Newcomb Pier. Within fifteen minutes the entire west end of the Municipal Pier was destroyed, sending more timber toward the Newcomb Pier. Pilings collapsed under Moby's Dock and the Newcomb parking lot. Three cars and a refrigeration truck toppled into the sea. Debris, stacked ten feet high in some places, was once again scattered along the coast south of the pier. By mid-morning on March 2, the storm relented, having taken about one-third of the Pier's square footage with it—an estimate \$6.4 million worth of damage.

The Santa Monica Pier was not the only victim of the March 1 storm. Piers at Seal Beach, Mission Beach, and Malibu's Paradise Cove were demolished as well. The sand surrounding the entrance to the concrete fishing pier in Venice washed away until it left the pier standing as somewhat of an island, inaccessible to the public. President of the United States Ronald Reagan toured the damaged Santa Monica Bay area via helicopter, noting the "devastation and the awesome power of the sea."

While the City Council had voted to quickly restore the pier after the first storm, the damage inflicted by the second was so devastating that the City acknowledged the process now would be much more difficult, time consuming, and expensive. Crews immediately began cleaning up the pier and shoring it up with new pilings in damaged areas, but the project of rebuilding the western sections of both the Newcomb and Municipal Piers would have to wade through the bureaucratic process.

By the time both of the 1983 storms had passed, one-third of Santa Monica Pier had been washed away. The west end was completely destroyed, as was much of the parking lot. Moby's Dock restaurant remained hovering precariously atop uncertain piles, and was later condemned.

-Ben Franz-Knight,

executive director of the Santa Monica Pier Restoration Corporation, 2008

TEN MOST OMINOUS STORMS

L. March 1, 1983

One-third of the Pier, including the entire west end, was washed away in the most violent storm the Pier has had to withstand.

2. January 27, 1983

The west end fishing deck and all of its businesses gave way.

3. February 1, 1926

Several pilings and a boat landing broke loose and battered the pilings that supported the La Monica Ballroom, forcing the ballroom to close for almost two months of major repairs.

4. April 18, 1926

Fishing boat captain T.J. Morris and two others drowned while attempting to save a boat loosened from its moorings by a major storm.

5. April 9, 1943

Nine boats were beached within Santa Monica Yacht Harbor, one of which was pounded to pieces as it crashed into the Pier's pilings.

6. January 2, 1925

Captain T.J. Morris rescued a party of three aboard a boat disabled by this violent storm.

7. October 20, 1941

Three boats were beached within the harbor and several others were saved by the Santa Monica Lifeguards.

8. December 21, 2005

Waves reaching ten to fifteen feet in height battered Santa Monica Bay. While the Santa Monica Pier easily withstood the beating, the Venice Pier was not so fortunate as the above-deck restrooms were swept completely off of the pier.

9. December 8, 1934

The long-awaited breakwater withstood heavy seas as area piers took severe beatings.

10. May 4, 1959

High seas took a heavy toll on boats moored within the harbor and its aging breakwater.

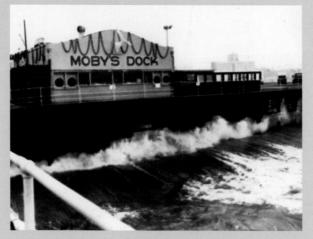

75

The Last Great Pleasure Pier

Restoration

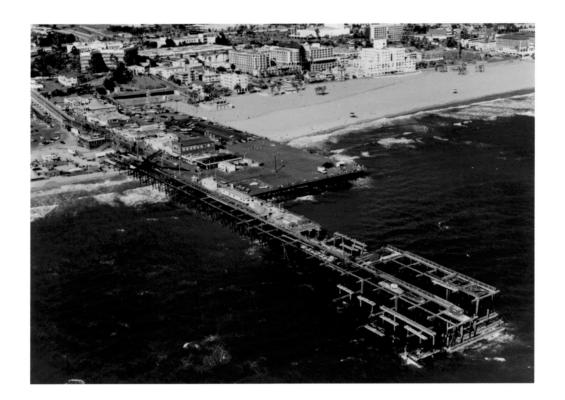

n the wake of the 1983 storms, the pier was nearly forgotten. For many, the entire pier had disappeared and was quickly becoming an afterthought—just a few pages in a history book. The City Council knew that was a dangerous misconception. So it focused instead on raising public awareness that there was still a pier in Santa Monica. The council designated a week in late May as Save the Pier Week, and established a committee to produce corresponding events.

The Save the Pier Week extravaganza opened on May 23, 1983, with a parade of Arabian horses, presentations by City officials and a series of jazz, reggae and country/rock concerts throughout the day. Festivities continued throughout the week, including art exhibits, a crafts fair, street performers, and enjoyable competitions including a pie-eating contest, a "cutest baby" contest, and a pier-building contest. Dances were held in the big

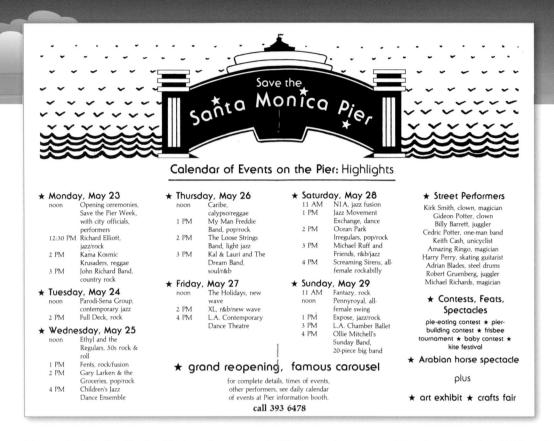

blue-and-white La Monica Tent, and concerts thrilled crowds every night, culminating in a Friday night show with performances by rock 'n' roll stars Ry Cooder and Christine McVie. A Sunday night film tribute featured movies filmed on the pier: *Inside Daisy Clover, The Sting* and *Elmer Gantry*.

In September 1983 the council made inaugural appointments to the Pier Restoration Corporation (PRC) Board of Directors, and the new board held its first meeting a few weeks later. Continuing with the goals set forth by the Pier Task Force prior to the storms, the PRC proceeded with plans to finance, design and ultimately rebuild the pier. Guidelines were established which would maintain the unique character of the pier while also exploring how to bring in enough revenue to support its operations.

In the spring of 1985 the PRC presented the public with two proposed plans for the new pier. One proposal called for a \$10.2 million wooden and concrete pier extending directly from the point where the pier then ended. The project would take about six to eight months to complete and would include a protective breakwater to be reconstructed and extended three hundred feet southward. The other called for an \$11.3 million all-concrete pier and concrete lower deck. Many of the Municipal Pier's surviving wooden pilings would be removed and replaced with concrete piles. This rebuilt version would take eight to ten months to construct, yet was considered strong enough to withstand storms without the aid of a breakwater. If the accompanying concrete lower deck were to succumb to a storm it would immediately sink to the ocean floor rather than crash into the pier's pilings as had happened in 1983. In addition, maintenance costs associated with an all-concrete pier were estimated to be far less than the combination wooden and concrete proposal. The public response was in favor of the all-concrete pier.

When the PRC proposed the all-concrete plan to the City Council in May 1985, the city attorney voiced con-

Save the Santa Monica Pier Week included a wide variety of events designed to build excitement while plans for Pier reconstruction were developed. Opposite: By 1989 the Pleasure Pier deck was complete and the west end was well underway. Alongside the Municipal Pier, a temporary pier was built to support the crane used for construction.

cern that the plans might be in violation of the Save the Pier ordinance passed in 1975, which stated that major alterations required a majority vote of the people. The council settled on a compromise plan that would use concrete pilings extending from the pier's current end and leave the existing structure standing on its wooden piles. The lower deck at the end of the pier would still be composed of concrete. The plans passed unanimously on May 21, 1985, and construction was slated to begin in the late spring of 1986.

Drawing on the positive experience of Save the Pier Week, the City's Arts Commission enlisted

producer Katharine King to organize a series of free concerts in June of 1985. Established as a tribute to the glory days of the La Monica Ballroom, the series was an instant success and evolved into an extraordinarily popular annual event known as the Twilight Dance Series.

PARKING

BLE FOR MOAT

... A New Era

On June 6, 1986, the newly remodeled east end of the pier opened. The new grand entrance and carousel park, designed by the Santa Monicabased architectural firm Campbell & Campbell, added new life to what had long been a dismal part of the pier's surroundings. The grand entrance recalled the tiered effect of the original Looff picnic pavilion and invited people up onto the new deck outside the historic carousel building. The park, with its giant stone dragon head and Viking-style boat, recalled mythical legends of sailing ships and sea monsters, providing children an outdoor playground. Temporary carnival rides, set up in the pier parking lot, accompanied the opening of the park, and were so popular that they were set up annually for the next decade.

Fourth of July fireworks celebrations, a beach tradition since Santa Monica's earliest days, continued to be a huge draw into the latter decades of the twentieth century. Both the pier and the surrounding beaches were annually inundated with people, but by the 1980s, incidents of violence were on the rise—there were several stabbings and shootings and numerous arrests. On July 4, 1986 the final nighttime fireworks show at the pier took place. A new approach was taken in 1987, when the city introduced "Dawn's

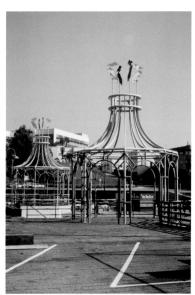

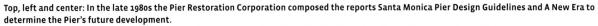

Top, right: Darrell Clarke emphasizes his views about the reconstruction of the Pier's west end in a 1985 community workshop.

Bottom: Gazebos were erected in the southeast corner of the Pleasure Pier, near the newly developed carousel park. They were designed to complement the silhouette of the Hippodrome (Carousel Building).

Opposite: A crane, sitting atop a temporary construction pier, aids workers rebuilding the Pleasure Pier.

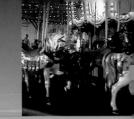

Early Light"—a fireworks celebration that began at 4 a.m. on the holiday. The early morning concept reduced neither the crowds nor the violence. In fact, most people stayed at the pier all night prior to the morning show, many of them intoxicated. Reports of violence, drunk driving, and mayhem actually increased. And overcast early-morning skies often led to disappointing visual shows. The rising cost of these events, when compared to the growing list of problems related to them, brought the City to an inevitable and unpopular decision. After the 1990 celebration, the City announced that Fourth of July fireworks at the pier would cease, a huge disappointment to the local community.

In November 1987, the Kiewit Pacific Company began reconstruction of the pier and progressed quickly. The Newcomb Pier was complete by August 1988 and the new west end's finishing touches were being applied as 1990 approached. Fishing decks were built on both the north and south sides of the new pier and a large, thirteenfoot-wide lower deck wrapped around the north and west sides at the pier's end.

On April 6, 1990, the new west end opened to the public for the first time. Mayor Dennis Zane presided over the opening day ceremonies and Joan Crowne, former owner of Al's Kitchen who had mortgaged her home in order to help save the pier in 1973, was awarded the first-ever Santa Monica Pier Prize. The new west end was overwhelmingly well received and the pier, as well as the rest of Santa Monica, felt whole again.

The people most ecstatic about the completion of the west end were the fishermen and fisherwomen. Robert Khourney made the first official catch off the new pier—a white sea bass. Staying true to the spirit of the old pier's history, though, the first fish were actually caught prior to the pier's opening day. John "Yosh" Volaski, a pier maintenance worker at the time, snuck out onto the end of the pier during the night before opening day and "unofficially" hauled in several sea bass.

In 1991 that very same fisherman, Yosh Volaski, opened Santa Monica Bait & Tackle Shop, the first

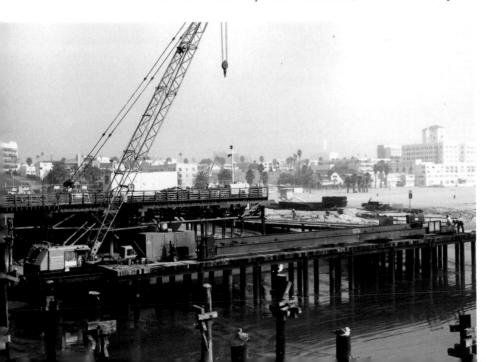

new business at the west end. For Volaski it was the crowning achievement of a lifetime spent on the pier. As a young boy, he frequently skipped school, followed the Red Line railway tracks to the pier, and fished all day. Finding a way to spend his working days on his beloved pier, he found work on fishing boats, in bait shops, and ultimately with the City's pier maintenance crew. When he got the chance to bid on the ownership of the new bait-and-tackle shop at the west end of the pier, it was as if he'd heard his calling.

As the new pier took shape, the PRC was confronted with how best to develop and operate the City's landmark. The dichotomy of maintaining the pier's tradition versus becoming self-sufficient was the topic of endless discussion. By the time the

The Last Great Pleasure Pier

new west end opened, Moby's Dock and the Shooting Gallery had been razed and Skipper's, a fast food restaurant on the northwest corner of the carousel, had been evicted. The Crown

and Anchor, an English pub-style restaurant which occupied the former Fish 'n' Chips space, was struggling, and many of the operators on the pier had begun to worry for their future. The Sinbad's building, hailed as a landmark and considered vital to the pier's profile, yet so decayed that it was hazardous—was demolished in April of 1993. Rumors circulated that major development and corresponding high rents were on the horizon.

The PRC, recognizing that this pier was the last remnant of an atmosphere that once defined Santa Monica, turned its focus to bringing back the amusement atmosphere that had delighted crowds for so many generations. While some locals were resistant to change, recreating a pier reminiscent of its earliest days while updating it with new restaurants, rides and attractions seemed the most sensible and profitable direction to go. The PRC set forth to find a suitable company to bring an amusement park to the pier.

In the summer of 1994, the restaurant/nightclub Rusty's Surf Ranch replaced the defunct Crown and Anchor. Owner Russell Barnard, guided by the same nostalgic sense that was encompassing the pier, re-established pocket billiards in the old Bowling & Billiards Building for the first time in over fifty years. Weekly pool tournaments at Rusty's revived the spirit of old "Pop" Kerns and even drew the interest of professional players like international trick-pool champion Mike Massey. With live music a regular part of its program, Rusty's became a mainstay on the pier with notable performances by nationally known acts such as Bonnie Raitt adding to an already popular schedule of local acts, like the Red Elvises.

In the summer of 1995 Mariasol Cocina joined the Harbor Patrol and Santa Monica Pier Bait & Tackle at the west end, delivering the nostalgic aroma of hot food on the grill wafting across the entire pier.

On May 25, 1996 Pacific Park opened its rides to the public, establishing the first permanent, fullscale amusement park on the pier since 1930, and with it came a renewed energy. Thrill rides included a new roller coaster, a dragon swing and a towering Ferris wheel named the Pacific Wheel. The Pacific Wheel quickly became the pier's new visual icon, but, after twelve years, the wheel succumbed to the effects of the marine environment. In May 2008 Pacific Park sold the wheel to an Oklahoma developer through the Internet

Santa Monica Pier

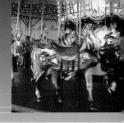

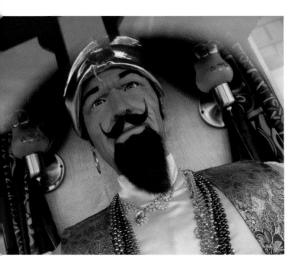

auction company *eBay* for \$130,400, half of which the park donated to the Special Olympics of Southern California. A new wheel, identical in physical size and specifications, was installed. The new wheel boasts one outstanding new feature—its lighting system with one hundred and sixty thousand new energy-efficient solar-powered LED lights, capable of changing colors

and patterns from one moment to the next. On May 28, 2008, the new Pacific Wheel was unveiled to the public, accompanied by the pier's first fireworks show since 1990.

The pier's history was honored in another reincarnation in 1996—this time under the deck east of the carousel. The University of California, Los Angeles opened the UCLA Ocean Discovery Center—an aquarium aimed toward educating the public, particularly children, about the ocean life found in Santa Monica Bay, much like Cap Watkins and his lifeguards proudly displayed next to their office in the La Monica Ballroom. In 2003, Heal the Bay assumed the operations of the aquarium, establishing a site "under the pier"

where school groups and the general public could get up-close views of local fish such as the California halibut, sarcastic fringehead and kelp bass. Interactive tanks are also available in which patrons can touch sharks, starfish and numerous other creatures found in the bay.

The quickly changing face of the new pier was not without its victims. Pacific Park, complete with games and its own bumper cars, supplanted those that had been on the pier for decades. Doreen the fortuneteller, a fixture on the pier since the 1940s, lost her space on the pier, but she and her family managed to stay nearby in a

new location on Ocean Front Walk, just east of the carousel.

The Boathouse, after thirty-five years on the pier, also found itself out of place in the pier's new atmosphere. During negotiations for a new lease, the city demanded major changes, including a cap on liquor sales, installation of a public elevator and improvements to the dilapidated structure.

Top: Zoltar invites visitors to get their fortunes at Playland Arcade. Right: In 2008, Pacific Park replaced the twelve-year-old Ferris wheel with a newer model. A fireworks show welcomed it aboard the Pier on opening night.

Opposite, top: During reconstruction, extra efforts like this bumper sticker reminded people that the Pier was still open. Opposite, bottom: The Santa Monica Pier Aquarium, operated by Heal the Bay, connects visitors with the natural marine environment of Santa Monica Bay.

82

"The Santa Monica Pier is not only a cultural, historic and commercial monument, it represents how community involvement can work to enhance, preserve and operate an important community asset."

-Bill Spurgin, former Pier Restoration Corporation Boardmember, 2008

Boathouse owners resisted, citing the expense of the elevator and extensive remodeling as unacceptable. In 2001 the city awarded the lease for the Boathouse property to the Bubba Gump Shrimp Company, a chain owned by Paramount Pictures Corporation. The community was outraged. Throughout the pier's life it had remained free of corporate-owned chains, yet the city was forcing out a family-run restaurant in favor of a corporate chain. Letters filled the local newspapers and angry citizens filled the City Council

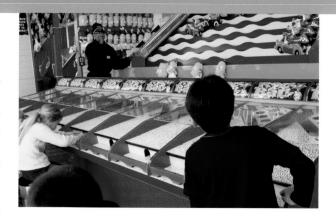

chambers, reminiscent of the days three decades earlier when the fate of the pier was at stake. This time, however, the protests failed. The Boathouse was evicted.

The pier's quick growth and upgrading did have the potential to invite corporate interests that would destroy the character and flavor of the pier. Chain restaurants had already found their way into Pacific Park, seemingly overnight. The PRC set language within the pier's leasing guidelines that discouraged the City from leasing to corporate chains.

Bubba Gump Shrimp Company opened its doors in November 2005. The newly rebuilt structure carefully resembles the restaurant it replaced. But, when customers walk through the establishment's front doors, instead of the sound of live music and the smell of stale beer, they immediately encounter an image of actor Tom Hanks jogging to the end of the pier in the film *Forrest Gump*, homage to the pier's longtime role as a movie star in its own right.

In the spring of 2008 the Trapeze School New York assumed the space left vacant by the Sinbad's building fifteen years prior. The site of the experienced and inexperienced flying through the air added to the whimsy on the pier, as does the daily presence of street performers. For many years, the City discouraged the presence of musicians and artists who performed in front of an open hat, but in 2001 the City drafted an ordinance that allowed for fair and organized street performance. The City Council reasoned that the pier, especially with its new

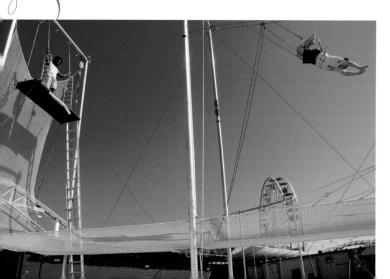

amusement park, was a natural location for these artists and entertainers. Since the inception of this ordinance, the pier has hosted mimes, tarot card readers, painters, calligraphers, acrobats, musicians and many other street performers. The most famous, Tim "Bubbleman" Dillenbeck, has become so regularly associated with his bubble-making performances on the carousel deck that he is one of the pier's featured attractions. His bubbles are said to have drifted as far as five miles away.

Top: Pacific Park's midway games entice those who are not eager to try the thrill rides.

Left: The Trapeze School New York began teaching people how to fly on the Pier in 2008. For those who'd rather watch than swing, it provides another form of entertainment on the Pier.

THE END OF ROUTE 66?

hat a romantic notion—the thought of driving iconic Route 66 all the way from Chicago to Santa Monica and taking in the sights and flavors of small-town America from Navy Pier to Santa Monica Pier. Every year countless groups of people come parading down the pier ramp in their cars, their motorcycles, even on their bicycles, and celebrate the end of their journey across the country's storied "Mother Road."

If only it were true.

While the Santa Monica Pier has often been labeled as the final destination of "Main Street of America," it just isn't so. There is a plaque in Palisades Park at the end of Santa Monica Boulevard, but that's not really the end either. According to the official record, U.S. Route 66 ends at the corner of Olympic Blvd and Lincoln Blvd. But, after traveling 2,448 miles across the hot desert of the southwestern United States, who wouldn't want to end the journey with a drive under the landmark blue sign onto the cool world-famous pier!

The composed image on this postcard, with a photo taken from Palisades Park at the end of Santa Monica Boulevard, adds to the continuous debate over the real endpoint of the world-famous "Mother Road"—Route 66.

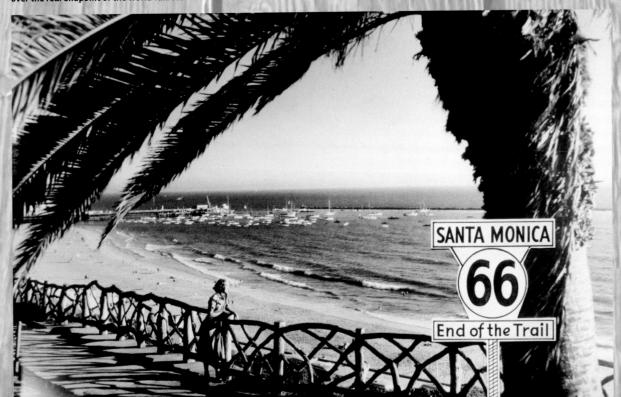

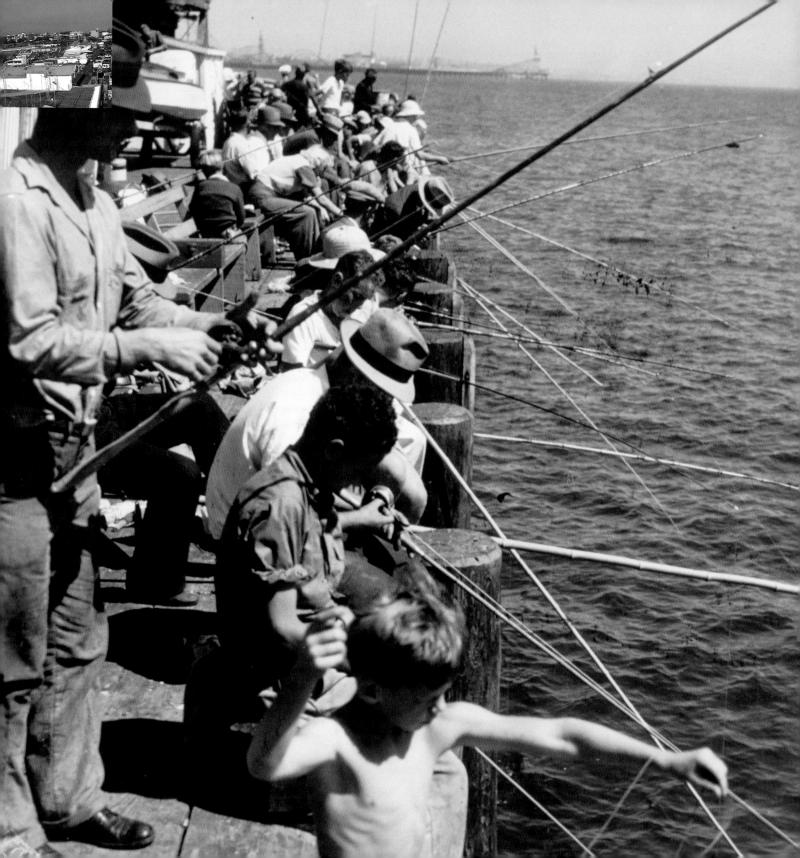

The Best Fishing in the Bay

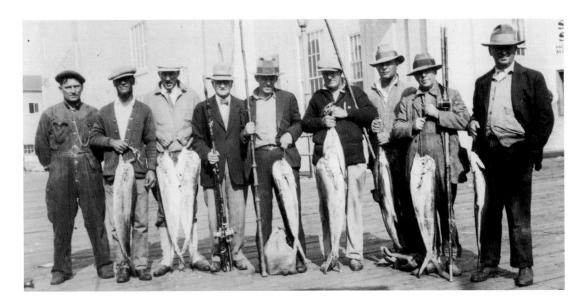

hen John McCreery landed the first yellowtail a week before the pier opened in 1909, word spread quickly—the Santa Monica Pier was one of the finest fishing spots on the coast. Not a day passed that the Municipal Pier wasn't crowded with anglers waiting to hook a halibut, perch, corbina or another finned prize. About the same time, an eighty-two-year-old man boasted that he fished at the pier twice a day, and would do so until the day he died. He did. Swarms of children regularly went to the pier after school to try their luck at landing some sort of sea creature. In July of 1910, a husband/wife team wrestled a thirty-five pound black sea bass onto the pier deck, the largest fish landed at the pier to that date.

Fishing gear ranged from primitive "jack poles" and "knuckle-busters" to the more elaborate rods 'n' reels—whatever could effectively haul a hooked critter up from its Pacific home was considered fair tackle. Small shops—stands, really—cropped up along the deck offering pole rentals and bait for sale, the first business enterprises on the pier.

Fishermen line up with Captain Dick Hernage (left) to show off their successful run of dolphinfish (mahimahi) caught from one of his fishing boats. Opposite: Fishing on the Pier's new west-end lower deck was very popular in the mid-1930s. Note the absence of safety railings at the Pier's edge. Opening spread: The defining icons of the pier in the early twenty-first century: the Pacific Wheel and the West Coaster.

87

Pier Icons

Some members of the fishing community assumed territorial behavior. Arguments erupted over fishing spots. But when the Looff Pleasure Pier was built adjacent to the Municipal Pier in 1917, a big group of fishermen were infuriated. The deck of the new pier was laid directly over the best haven for croakers in the entire bay. Captain Al Green, superintendent of the Municipal Pier, quickly retracted a joking suggestion that the fishermen cut holes in the wooden deck and drop their lines through to the ocean (much like ice fishermen do on frozen winter lakes) for fear that some irate anglers would take him seriously and pose a hazard to pedestrians.

On June 23, 1922, W.H. Bakerbour landed a fish shattering all previous records. The fish, a 450-pound black sea bass, took over an hour and every ounce of Bakerbour's strength to land. The pier experienced a run on these fish in the early 1920s, but fishermen on sport

fishing boats caught them more often. Sometimes referred to as Sea Hippos, the fish could reach a length of eight feet, weigh over five hundred pounds and could live to be over sixty years old.

For anglers who weren't satisfied with simple pier fishing, boating operations offered daily service from the pier's west end. In the summer of 1921 Captain Thornton J. Morris began the pier's first fishing excursion boat operations. T.J., as he was known, offered private charters aboard the sixty-foot cabin cruiser *Ursula* and the speedboat *Josie M.* and within a couple of years he expanded the fleet, adding the sixty-foot *Ameco*, the *Palisades*, and *W.K.* Competition followed. By the mid-1920s the pier offered sportfishing fare aboard boats such as Dick Hernage's *Scandia II* and *Bright*, Olaf Olsen's *Harold O.* and *Viking* and Scotty Lacade's *Kitty A.* For those less adventurous about taking a day trip, but still willing to brave deeper waters, a small fleet of fishing barges was anchored in the bay and fishermen took water taxis to reach them.

Sportfishing and barge businesses thrived on the pier for the next several decades until their popularity

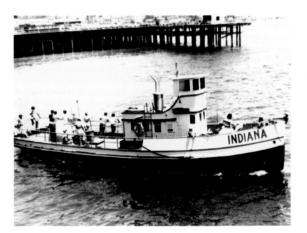

AT SANTA MONICA

SCANDIA II

"BRIGHT

Anglers remain the most loyal visitors to the pier. Occasionally a run of bonito will swarm the pier, jolting it full of so much energy and life that it's easy to conjure the excitement of those days when the pier was the fishing capital of Santa Monica Bay. Perhaps that's the real reason fishermen come to the pier each day—any day might be that day.

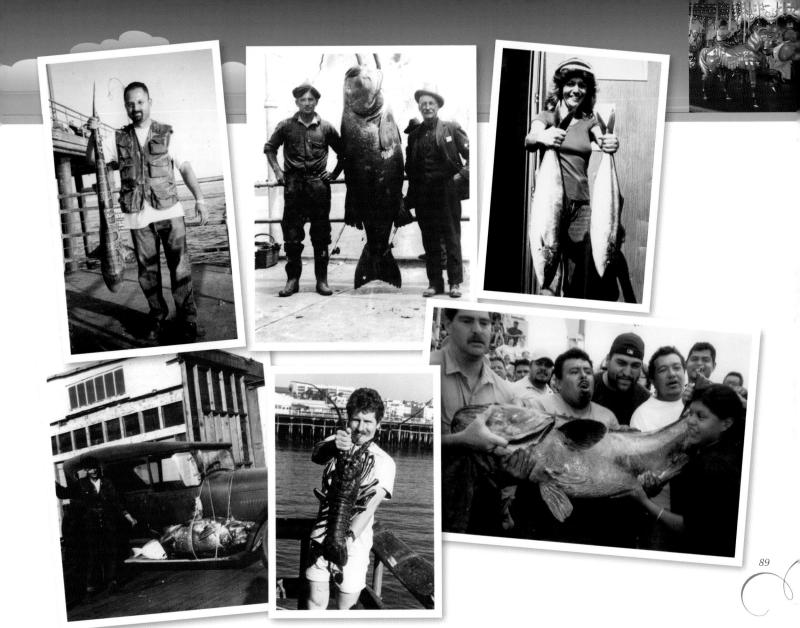

Clockwise, from top left: Leopard sharks are commonly caught from the Pier; longtime Pier businessmen Dick Hernage and Frank Volk pose beside a giant black sea bass in the late 1920s; a woman poses with two yellowtail tuna caught while aboard one of the Pier's fishing boats; in 2006, a black sea bass was caught from the Pier, the first in several decades (it was later released); lobster are easy to find around the Pier, especially in the remains of the breakwater; Dick Hernage prepares to take this black sea bass home in the 1920s.

Left and opposite, bottom: The *Kiaora* and *Indiana* took passengers on fishing trips from the Pier until the west end was destroyed in 1983. Opposite, top: The *Scandia II* and the *Bright* were very popular fishing boats operated by Captain Dick Hernage.

THE PIER'S PETS

OSCAR THE PENGUIN

"Oscar the Penguin" was a favorite at the Ocean Park Pier, but when his home closed for repairs in the 1930s, Oscar was given temporary quarters at the Santa Monica Pier Aquarium. He and lifeguard chief "Cap" Watkins immediately bonded. Soon, though, Oscar made a nuisance of himself by eating the aquarium's prized fish! Watkins resolved the situation by walking his new friend to be fed at Frank Volk's bait shop for the remainder of his stay.

BALDY THE YELLOWFIN

Captain Al Greene, custodian of the Municipal Pier in its earliest days, boasted about a pet yellow-fin which he nicknamed "Baldy." Indeed, a fish's survival can be particularly challenging when its habitat is near a fishing pier, but the clever fish was uniquely adept at avoiding fishermen, and greeted Captain Greene daily at his favorite spot. In 1916 Baldy disappeared, leaving the Captain in dismay. Two months later Baldy made local headlines when he returned to his beloved friend.

CHARLIE THE PELICAN

Pelicans are very common to the Pier, but none has struck the public quite like the one known as "Charlie." People remember seeing the large bird perched aside the live bait tank on the Pier's west end as early as the 1950s. Everybody's pet, Charlie was a friendly, yet finicky bird. He hated to be touched, but loved to be fed (in fact, he expected it). He would only eat live fish, and the food had to be thrown directly into his mouth. He would never be caught scrounging deck boards for errantly thrown meals! He remained a beloved fixture on the Pier until the west end was swept away in the 1983 storms.

90

Santa Monica Pier

91

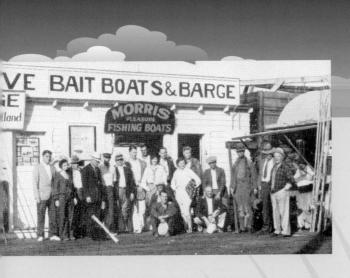

MOSSIZ FLEST OF THE THE TEXAIC TYLE

J. Morris, the man who started it all, was the pier's most unfortunate fisherman—tragedy struck him in threes. First, on the night of April 3, 1924, the *Ursula* broke free from her mooring and began to drift out to sea. Morris, determined to rescue his prized boat, caught up to her in a small skiff, climbed aboard, and attempted to start her gasoline engine. The engine backfired, ignited the *Ursula* and nearly took his life. Morris was able to escape the floating inferno, drifting away aboard the same skiff he rowed out on. Fishermen on the Municipal Pier rescued him later. In 1926, the Morris flagship *Ameco* broke her mooring during a February storm. The boat drifted into the Municipal Pier, battered against the pilings hard enough to cause extensive damage to the pier, and ultimately was smashed to bits.

On April 8, 1926, Captain Morris again found himself chasing after one of his vessels. This time it was the W.K. that broke loose in a storm and found itself on a course bent on ramming into the pier. Morris and two crewmen, Leo Gregory and Paul Brooks, jumped aboard a small skiff and set forth to rescue the drifting ship. As the three men approached the W.K., a massive breaker overturned the skiff, casting all three men into the sea. Moments later they reached and righted the skiff, as a growing crowd on the pier watched. Captain Morris struggled to save one of his crewmen, so his son-in-law Jack Duggan quickly organized a rescue party. The team rowed toward the accident while lifeguards jumped into the ocean from the beach, carrying rescue cans to help the struggling sailors. All efforts were futile. The crew disappeared from sight. Leo Gregory was the first to be found as he lay dying underneath the Crystal Pier, about a half-mile south. The bodies of Paul Brooks and T.J. Morris were recovered a few days later.

The W.K. fared far better—she washed ashore several hundred yards away from the pier. The W.K. continued service in the Morris fleet under the stewardship of T.J.'s cousin Clifford Morris. The fleet expanded in 1929 to include new boats I.K.I., Lois, Colleen, Morris Owl, Lark and a second Ameco.

On May 30, 1930, a Memorial Day excursion aboard the new *Ameco* went terribly awry. The fishing boat had been loaded beyond its passenger capacity and headed into rough seas near Santa Monica Canyon. A strong wind whipped showers of water across the boat, causing most of the passengers to assemble on its lee side to avoid the annoying spray. A huge swell caught and capsized the already listing boat, sending all of her passengers into the ocean. Another fishing boat, competitor Dick Hernage's *Freedom*, was fortunately also in the area, and was able to pick up many of the castaway passengers. Since records on excursion boats were poorly kept at the time, nobody was certain how many people were aboard the *Ameco*. After a long search during which fifty-four people were rescued, it was determined that sixteen people had probably perished. The lack of clarity surrounding the incident combined with the overcrowding of passengers drew serious scrutiny from both the Coast Guard as well as city and county governments, and new regulations were quickly adopted to avoid such a horrible event from occurring again.

The Carousel & Hippodrome

n June 12, 1916 the Looff Hippodrome opened its doors for the first time and the public fell in love, for inside the curious-looking structure was a circling menagerie of wooden animals suited to delight anyone who cared to ride upon them. It was a genuine carousel. The music of an automatic band organ, manufactured by A. Ruth & Son of Waldkirch, Germany, accompanied the animals. The organ's sound could be heard well into the town, drawing people toward its melody and the stable of fun inside.

The Hippodrome, a mixture of Byzantine, Moorish and California architecture, is a two-story structure measuring just over one hundred feet square. Its swooping roof and corner turrets give the building a whimsical

The oldest building on the Pier, the Hippodrome (often referred to as the Carousel Building) is listed on the National Register of Historic Places.

Opposite: The merry-go-round inside the Hippodrome is a 1922 Philadelphia Toboggan Company carousel. It was installed inside the Hippodrome in 1947 by Pier owner Walter Newcomb.

93

Pier Icons

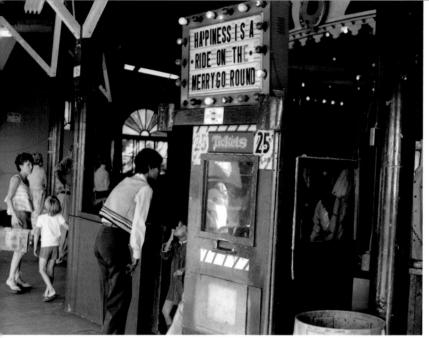

allure. The second floor was built as both office and apartment space, housing the owners and management of the new pier's development project.

The carousel inside was a Looff original, hand-crafted by Charles Looff himself. It offered a mixture of hand-carved horses, giraffes, camels, tigers and other jungle animals, all jumpers—animals that move up and down—spreading three rows across the revolving platform. Brass rings were dispensed, awarding free rides to the lucky recipients. The ride was so popular that, within three months of its first run, it was expanded to include an outer row of twenty-four additional animals. Surrounding the carousel were rocking chairs where non-riders could relax and watch the wooden animals and their passengers circle around.

In 1939, while the amusement pier

struggled with ownership issues, the Looff carousel was sold to the Belmont Park amusement park in Mission Beach, San Diego. It remained there until 1976, when it was disassembled and sold off in pieces. A C.W. Parker #316 carousel, previously housed on the Ocean Park Pier, replaced the Looff unit. The Parker, made in Leavenworth, Kansas, in 1916, was originally built for use in a beer parlor, but the timing of Prohibition relegated it to storage for several years before it found a home on the Ocean Park Pier in 1925.

The Parker carousel remained in the Hippodrome until 1947, when Walter Newcomb sold it to make room for his own carousel, the Philadelphia Toboggan Company #62. Newcomb found it in the 1930s through a classified advertisement in *Showman's National Magazine*. He sent his brother Ted to inspect it, who then bought it on sight. He first installed the carousel on the Venice Pier, but when that pier burned in 1947, Newcomb moved it to its new home in the Hippodrome. The Philadelphia Toboggan Company #62 carousel remains there today as one among only a handful of historic, all-wooden merry-go-rounds in operation.

A standard Philadelphia Toboggan Carousel, its two interior rows consist entirely of jumpers, while the horses on the outer row are all standing. The noble animals number forty-four in all. Interspersed among them are two sleighs suitable for riders who prefer not to climb on a horse. The music accompanying the horses today alternates between recorded selections and those provided by an original Wurlitzer Model 146 Automatic Band Organ.

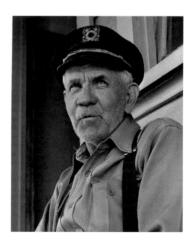

"We all go through stages, you know? First we ride it as kids and stop. Then we ride it as teenagers and stop. Then we bring our kids and when they stop, we stop . . . and then our grandchildren." —George Gordon, owner/operator of the Carousel, 1977

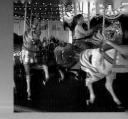

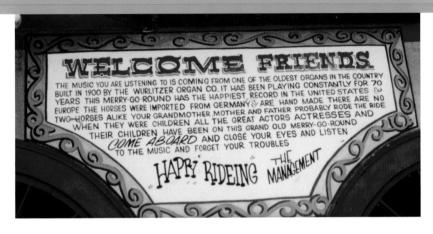

In 1954 George and Eugene Gordon assumed management of the carousel. The brothers eventually bought the business and upgraded the manually operated crank machinery to the more modern electrical system that exists today. They made only a few other changes during their ownership, the most significant

being the removal of the brass ring dispenser in the early 1970s.

Longtime carousel operator Jockey Stevens not only worked in the carousel, he lived in one of the upstairs apartments. A quiet man with a weathered face, he assisted children and adults alike onto the horses, taking their coin-fare and depositing it into his change belt. He is credited with painting the postcard-like scenes which circle above the horses. Perhaps most notable, though, was his strange encounter with a mysterious woman. In the early 1960s, an unknown woman, whose identity was concealed by an overcoat, sunglasses and dark wig, regularly visited the carousel. The woman never rode the horses, just watched them circle around. Jockey, whose utterances were usually limited to only a word or two, approached her one day. While nobody is certain of their exact conversation, the woman uncovered her face and smiled, revealing her true identity. She was Marilyn Monroe.

On July 16, 1976, Thom O'Rourke and Mary Anne Hatala arranged to have their wedding ceremony performed on the carousel, exchanging vows while it was operating. It was a second marriage for both of the betrothed, and the groom wished to surprise his bride and her seven-year-old daughter with the special marriage site. It was the first wedding at this historic site, and many more couples have since used the unique venue for their nuptials.

In 1977 the City of Santa Monica bought the carousel and the Hippodrome from the Gordon family for one hundred thousand dollars. The building and the horses had seen so much wear and tear throughout the years that the City ordered a full restoration. In 1980, they hired the sister/brother team Tracy and Steve Cameron to restore the horses to their once-beautiful condition, while the building was stripped of its yellow stucco and red trim and refinished with the original colors of tan with blue trim. The rocking chairs surrounding the horses were replaced with a fence and gated entrance that helped to prevent people from attempting to jump on to the merry-go-round as it was operating. The process took several months, and in June 1981, the newly finished horses were once again made available to the public. Carousel enthusiast Barbara Williams, the instigating force behind the restoration, assumed management of the carousel's operations in 1983 and continued with her labor of love for several years.

Among the last of its kind, the Hippodrome was adopted into the National Register of Historic Places on February 17, 1987. A bronze plaque denoting its landmark status is mounted on the north wall of the Hippodrome.

Everything about the carousel is special, as this sign hung atop the building's entrance in the 1970s attests.

Opposite, top: The ticket booth says it all: "Happiness is a ride on the merry-go-round."

Opposite, bottom: "Jockey" Stevens collected the fare from merry-go-round riders for many years. An inherently quiet man, he became part of Pier lore after a chance encounter with a famous mystery woman.

LIFE ABOYE THE HORSES

ome living spaces have inherent character. Some develop character through the people that have inhabited them. A very distinguished few are fortunate enough to have been touched by both. This is particularly true of the apartments above the carousel.

When the Looff family built the Looff Pleasure Pier in 1916, the first building erected was the Hippodrome. To be present during the construction, the Looffs took up residence in the newly built rooms on the building's second floor. While their residence there only lasted through the construction period, they were the building's first inhabitants.

George Reid, one of the Looffs' managers for the construction project, also took advantage of the convenient living quarters so close to his work. He and his wife Winifred actually stayed there for several years, ample time to give birth to three children—George, Winifred and Catherine—inside their cozy apartment above the parading horses.

Since then, many people have called these unique living spaces home. As part of the magic that surrounds it, rumors have swirled about famous residents—no, Marilyn Monroe, Bob Dylan, Joan Baez and Herb Alpert didn't live there, despite the legends. Nevertheless, those residents who actually lived above the horses were an interesting bunch. Artists, writers, poets, scientists or just plain oddballs, the honored list is as wide-ranging as is the description of those who have ever visited the pier.

Iris Tree, an English poet and the daughter of actor Sir Herbert Beerbohm Tree, was one of the more notable occupants in the early 1950s. Though William Saroyan never officially lived in the Carousel, he rented one of its rooms as a work studio with friend and fellow writer Jimmy Henderson. Paul Sand, comic actor and playwright, lived in the southeast corner for a year in the late 1950s, trying desperately to sleep in on weekend mornings while the Wurlitzer organ piped its merry, yet very loud, tunes. He left in 1959 for France where he would study in the more peaceful environment offered by mentor Marcel Marceau. Ed Deland, then an executive with the RAND Corporation, lived there for fifteen years—despite the unremitting organ music.

One of the more notable and recognizable tenants was a woman named Colleen Creedon. A prominent Santa Monica activist, Creedon utilized her unique living quarters to host fundraising parties to support the plights of César Chávez and Daniel Ellsberg. Regular attendees of her parties included a handful of celebrities that were her friends. It was not uncommon to see Herb Alpert or Joan Baez climb the stairs to pay her a visit—presumably the root of the rumors. She also organized the pier's celebration of Sun Day, a na-

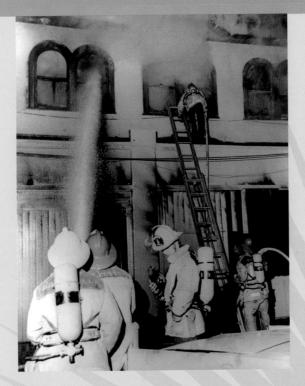

tionwide environmental event intended to raise awareness of the viability of solar energy. In fact, she even designed plans for a completely self-sufficient pier, powered by the sun, wind and waves of its very environment. Beyond her activism, she was a vivacious member of the pier's every-day life. She is often remembered and referred to fondly as the "Lady above the Carousel", although her grandchildren gave her favorite label to her. They referred to her then, and still do today, as "Merry-go-round Granny".

In March 1974, the magical days of life above the horses came to an end. On March 4, arsonists set fire to the Carousel Building just below Creedon's apartment. Creedon actually saw the two young men set the fire and placed the 9-1-1 call to the fire department. Her husband bravely attempted to douse the flames with a fire extinguisher, but the fire spread too quickly. Thurber, the family dog, was trapped inside. Firemen arrived to battle the fire and managed to pull Thurber out through a window. They successfully put the fire out, but the damage to the building was already extensive. Within days, City officials ordered

that the carousel apartments be vacated. The apartments above the horses became but a memory.

Some time later the idea of a possible conspiracy entered Creedon's mind. While visiting with friends, she found out that the homes of two other female activists were targets of arson during the same week that she lost her cherished apartment. While she'll never know if she was a victim of political spite, she will always wonder . . .

In the 1980s, after the carousel's restoration, the rooms above the horses were re-inhabited, but not as apartments. Today, the music that surrounds the circling horses drowns out the clicking of keyboards and the ringing of telephones from what are now the offices of the City of Santa Monica's Environmental Programs Department and the managers of the pier, the Santa Monica Pier Restoration Corporation.

Top: A 1974 fire put an end to what was certainly among the most unique living spaces in the world—the apartments above the merry-go-round. Left: Music legend Joan Baez reminisces aboard a merry-go-round chariot with longtime friend and former Hippodrome apartment-resident, Colleen Creedon, in 2007.

Opposite: Joan Baez enjoys a visit with Creedon inside her apartment, 1970.

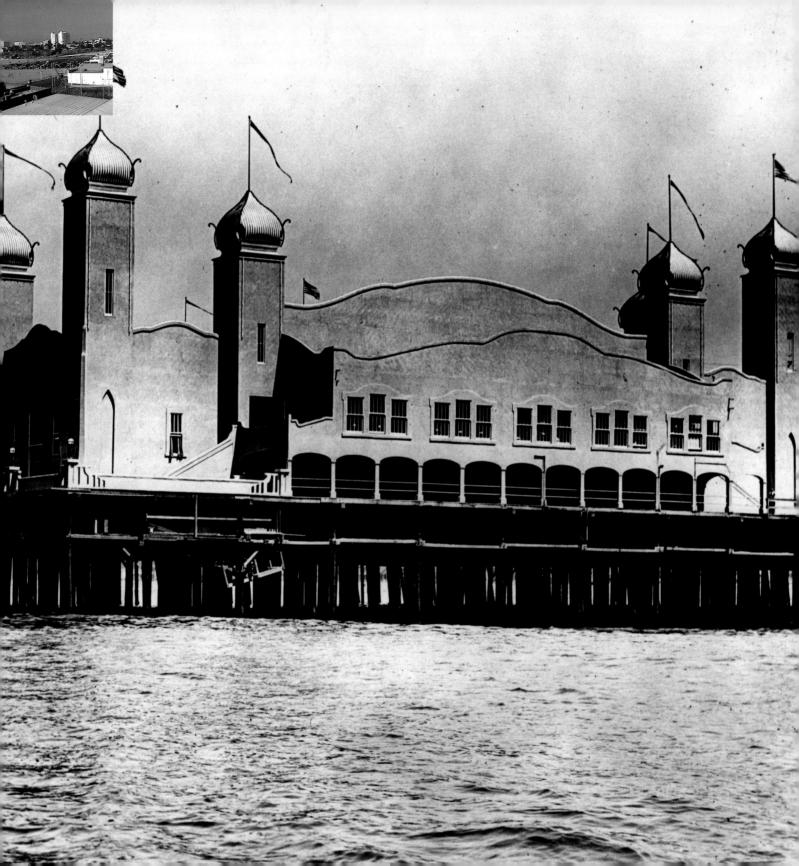

The La Monica Ballroom

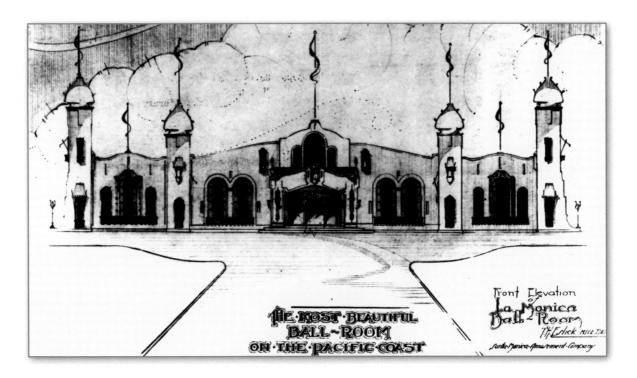

hile the carousel building is by far the oldest, most established building on the pier, the La Monica Ballroom survives in memories and photographs as the most enigmatic. More than just a ballroom, the structure more closely resembled an enormous palace hovering over the sea. Its heyday was during the pier's most difficult years—an era of insecurity, uncertainty and, at times, despair. Its mere existence brought an occasional ray of hope, whether as the ballroom it was built to be or as any of its other incarnations.

Hired to design the La Monica Ballroom, architect T.H. Eslick certainly knew how to make an impression. Built upon a footprint of more than forty thousand square feet and advertised as the largest ballroom in the world,

Santa Monica Pier

the structure looked completely unique in its setting. Twelve minarets, extending from each corner, combined with its curved facades and roof, to offer a Spanish-style appearance, and the stucco exterior was designed to give the building the appearance of ancient stone. To decorate the interior, Eslick hired a group of Russian artists to create a submarine garden where dancers could revel in the illusion of dancing at the bottom of the ocean. Upholstered chairs and sofas provided exquisite comfort for the ballroom's guests, and extraordinary bell-shaped chandeliers floated above the ballroom floor, providing the only visible source of light-although it was obvious that other, hidden light sources were added to provide the ballroom's illumination. The lighting system, both interior and exterior, was so extensive that the ballroom needed its own power facility, complete with three 120-horsepower engines which powered two generators.

Careful thought was given to each detail, all the way down to the management of the dance tickets and the location of the refreshment booths. The special "spring floor," which Eslick had designed himself to provide the most comfortable surface for dancing, received a lot of pre-opening buzz. Thirty-five

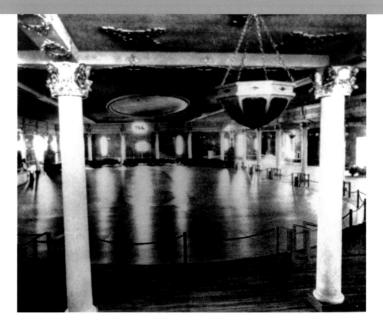

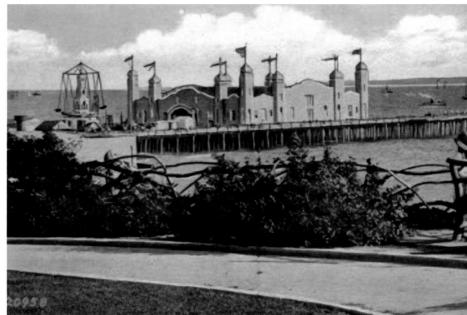

Top: The dance floor of the La Monica Ballroom was composed of 35,000 strips of hard maple wood.

Bottom right: The ballroom's Spanish-style minarets and curved façade gave it a very distinct appearance.

Opposite: The dance floor was surrounded by smoking rooms, parlors and restrooms.

—Santa Monica Evening Outlook, July 26, 1924

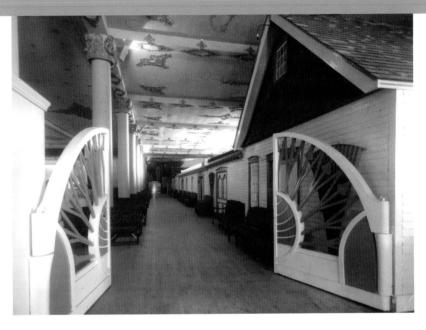

thousand strips of hard maple were used to pattern the exquisite 15,000-square-foot floor.

It was no surprise that the ballroom drew as many as fifty thousand people to its premises on opening night. It was perhaps the most advertised affair Santa Monica had seen to date. Don Clark's Orchestra, among the most popular acts in the Los Angeles area at the time, was the night's featured performing artist. Dance tickets sold out right away, and the entire ballroom was limited to standing room only throughout

the gala event. Even with the flow of those attending just to have a look inside and then leave, the building was filled to capacity all night.

Ballroom attendance continued to thrive well after the dramatic opening night. Roy Randolph, a well-known local dance instructor, became a house fixture, teaching students of all ages and actively participating in the ballroom's special programs for Halloween, Christmas and New Year's Eve. Don Clark's Orchestra played regularly, welcoming in guest artists like tuba player Carl Angeloty and band director Paul Whiteman. Film stars such as Bryant Washburn and Creighton Hale made guest appearances on a regular basis as well. The big dance craze at the time was the Charleston, a provocative number originally developed to accompany the song of the same name, and the La Monica capitalized on its popularity by hosting regular Charleston contests.

The great ballroom seemed invincible at the time, its popularity redefining the entire Santa Monica Pier. The ethereal vision of it floating above the ocean was perhaps even a bit symbolic. The humbling reality of nature voiced its authority, however, in the winter of 1926. On February 1, a storm devastated the California coast, completely destroying a small pier built at Santa Ynez Canyon and tearing loose pilings from the Municipal Pier. A boat landing that had been attached to the Municipal Pier broke loose and proceeded to rip loose piles beneath the La Monica Ballroom. The damage to the substructure caused the La Monica floor to sag and the entire structure to sway.

Repair of the pier and ballroom began almost immediately. The Santa Monica Amusement Company, owners of the pleasure pier and the ballroom, hired Arthur Looff as a consulting engineer. Looff, happy to revisit his family's former enterprise, eagerly devised a method in which the new piles could be driven through the floor of the ballroom by means of hydraulic jettying. The process saved an enormous amount of time and money since the construction inflicted little damage to the rest of the structure. By early March, the work was complete and the ballroom was completely redecorated. The spring floor, completely destroyed by the storm, had been replaced by a new hardwood floor, touted to be even better than its predecessor.

On March 25, 1926, the La Monica Ballroom held its grand re-opening celebration. Advertisements adorned

102

the local newspapers much like they had during the original opening. Hollywood celebrities such as Sally Rand were scheduled to appear, and Don Clark was once again tabbed to play the opening. The doors opened to a crowd estimated to be between five thousand and ten thousand, and the ballroom's popularity picked up right where it had left off. Dance contests, at this time featuring the waltz or the Foxtrot, were a

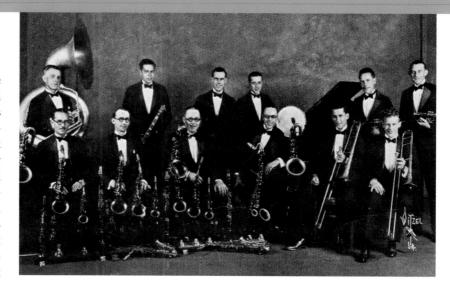

regular draw. On Friday nights, contests for a new dance called the Straight Collegiate became very popular.

In August 1929 the City of Santa Monica hosted the National Women's Air Derby, an airplane race from Santa Monica to Cleveland, Ohio, which featured the world's top female pilots. On August 17, the night before the great competition, the La Monica Ballroom hosted the Santa Monica Aviation Ball in honor of the acclaimed flying women. Competitors in the race and attendees at the ball included Florence Lowe "Pancho" Barnes, Ruth Elder and the most famous female pilot in history, Amelia Earhart. The race ended in Cleveland nine days later with Earhart finishing third place behind Louise Thaden and Gladys O'Donnell.

In the summer of 1932, the La Monica offered relief for people who were out of work by hosting endurance contests. Originally introduced as "Walkathons," the events evolved into competitive dance endurance contests known as "Dance Marathons," a phenomenon that had become quite popular throughout the Nation. The spaciousness and reputation as an entertainment venue made the La Monica an ideal locale for these entertaining, yet grueling, contests. Couples would compete for cash prizes ranging from one hundred to one thousand dollars by dancing nonstop for hours at a time, taking breaks only to eat and get a little bit of rest. The ballroom floor easily reached its five-thousand-person capacity at the onset of these marathons, and the contests regularly exceeded five hundred hours before a winner was determined. The entertainment element was vital to the events; quarrels were staged and some competing couples were even married at the event. Brilliantly portrayed in the book and film *They Shoot Horses, Don't They?*, the contests were ultimately a very disturbing form of self-torture and unfulfilled hope for its participants. By the end of that summer the City Council deemed that the endurance contests were too brutal, and passed an ordinance outlawing any contest that would force participation for more than twenty-four hours.

In 1934, the City of Santa Monica was in need of a venue that could host large conventions, and entered into a lease agreement for the ballroom. The City's plan was to use the La Monica to the fullest of its capacity. Not only would it be the host venue for large conventions, but the weekly civic dances would be held there as well. Offices were also allocated for the Santa Monica Lifeguards and the Harbor Department, and the remaining spaces

were leased to individual operators for a restaurant and other concessions.

Remodeling of the ballroom began the following December. Lumber salvaged from movie studios was used in order to help keep expenses under control. Construction began with the lifeguard headquarters, located on the northeast corner of the massive structure. A special watchtower was created in the minaret above the lifeguard offices, and the notion to install an aquarium inside the quarters was conceived.

POPEYE SENDS "BEST FISHES" TO AQUARIUM

he original suggestion for the location of the aquarium was on the newly constructed lower deck on the Municipal Pier, but the logical location of the display was inside the ballroom, under the supervision of the lifeguards. A four-thousand-pound tank and two smaller tanks were installed next to the headquarters in the recreation hall of the ballroom.

James G. Frances originated the concept of displaying fish on the pier, and the plan quickly gained the support of many Santa Monicans, including television star Leo Carillo and comic strip writer E.C. Segar, the creator of "Popeye." Segar went so far as to share a letter of support from the famous animated sailor:

Dear Mr. Frances;

Tha's what I think too. Santa Monica should oughter have a aquarium. Folks loves to watch little fishes flittin about. It sorta makes 'em relax an' feel kind of susperior. Gazin' at sculpin or barrycudales or even

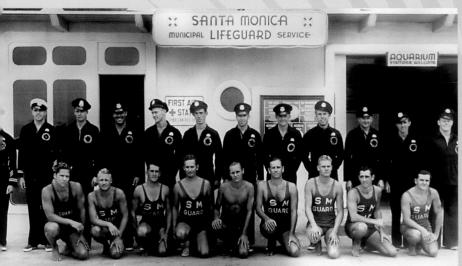

wonderful things hooman beings really are. So if a aquarium will make folks feel importink, then I sez, less have us a aquarium right here in good ol' Santa Monica. They's hunerds of reasings why we should have a aquarium an' ya kin put me down as bein in favor of it if ya'll promiss ya won't ast for no blasted donations. A' course if ya'll put in a bait tank for anchovies I might kick in with a donate.

Best fishes to you, I am: Yers truly Popeye

The Santa Monica Lifeguard Service operated the Pier's first aquarium inside the La Monica Ballroom. Displays included only ocean-life found in the local waters.

103

Pier Icons

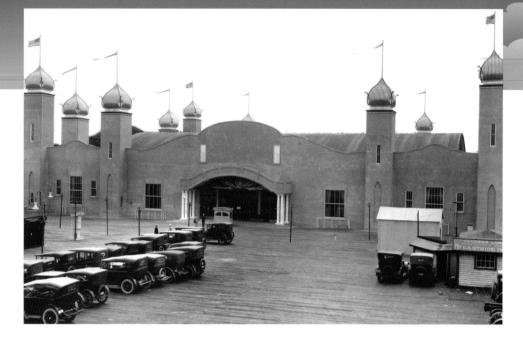

The City moved its traditional weekly civic dances into the ballroom while construction proceeded, and held a New Year's Eve dance on December 31, 1934. Remodeling was complete in the summer of 1935, and on July 18 the La Monica Ballroom held yet another grand reopening as the La Monica Convention Auditorium and Recreation Hall. The aquarium opened as well, drawing large crowds every day. Charlie Chaplin and Paulette Goddard were regular visitors, enjoying the display of garibaldi, small leopard shark, and other fish found locally in the bay.

In May 1938, the ballroom was losing profitability and underwent another conversion, opening as the "Rollaway Roller Rink"—quite a distinct change from its previous uses within the community. As it turned out, the floor was quite suitable for skating.

In the latter part of 1938 Santa Monica was in the process of building a new city hall, and the timing of the

construction was such that the existing city hall building had to be vacated. Offices were subsequently relocated to various locations throughout the city and the La Monica was chosen as the new, temporary location for the police department and jail. During this period, the building that was once hailed as the largest, greatest ballroom in the world housed the city's lifeguards, police and prisoners in close quarters with fun-seeking roller skaters.

Top: Parking was available on the deck immediately in front of the entrance to the ballroom.

Left: Desi Arnaz and Spade Cooley revived the ballroom as a live music venue during the late 1940s.

THE PIER AS JAIL

he temporary jail had quite a life of its own, despite its brevity. Twice there were reported jailbreaks, incidents that had not occurred in Santa Monica for many years. The first attempt was a futile endeavor by a seventeen-year-old boy confined in the jail's juvenile cell, charged with being a runaway. The boy tied blankets together, fixed one end to a water pipe, and threw the other end out the window. He began to climb through the window, only to discover that he was too big to fit through. A lifeguard passed by a short while later, saw the boy's dangling legs outside the window, and contacted the police inside.

The second jailbreak was considerably more successful, though not completely. A twenty-nine-year-old man who had been booked for robbery escaped early in the morning, by prying the steel grill from his cell's window, climbing outside and leaving the pier by foot. His absence was discovered at 7 a.m. and a radio alert was sent out immediately. Two police officers happened to see the escaped prisoner hitchhiking a few miles away at the corner of Wilshire and San Vicente in Los Angeles just as the alert came over the radio, picked him up and immediately brought him back to the pier jail. Upon questioning the man, police discovered the night watchman had given him a can of snuff from which he used a sharp piece of steel to loosen the jail window's grill, thereby enabling his escape.

Albert Otis Bryan, a twenty-nine-year-old man arrested for robbery, explains to a police officer exactly how he escaped the city jail, which was temporarily housed in the Pier's ballroom.

Pier Icons

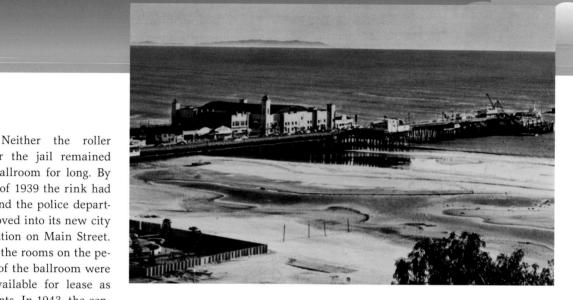

ter of the ballroom was even used for badminton competitions, but it wasn't until the late 1940s that new life truly began to be infused into the great building.

Western Swing music swept the nation throughout the 1940s. It first achieved popularity just prior to World War II and again after the war. The ballroom welcomed the new sound, reopening as an entertainment venue. The name La Monica had not been used since before the facility's convention center days. For a brief time, the renewed venue was dubbed the Western Palisades Ballroom and then the Santa Monica Ballroom. Regardless of the name, Western Swing was the new game, and it played well.

Spade Cooley, famous for the 1945 hit "Shame on You," was the self-proclaimed "King of Western Swing,"

and in the 1940s he established a home in the ballroom. His regular appearances there became so popular that, on August 5, 1948 TV station KTLA made Cooley the first variety act to be performed live on television. His show, called the "Hoffman Hayride," immediately became one of the most popular weekly television shows on the air. Called the "Hoffman Hayride" to call attention to the show's sponsor, a TV-set manufacturer, the production focused entirely on Cooley and his band. The name was eventually changed to "The Spade Cooley Show." Stan Chambers, longtime news anchor and familiar face on local television, got his start doing commercial spots for Cooley's show during its heyday.

Dick Lane, also of KTLA, did live car commercial pitches direct from Cooley's show and created a bit of his own television notoriety. During one of his broadcasts, Lane got frustrated with the crowd talking over him, so he pounded his fist upon the advertised car's fender. This quieted the crowd and drew the attention that he desired, so Lane adopted the routine as part of his act until one night he hit the fender so hard that it fell off the car, resulting in what has since been regarded as a classic comic moment in live television history.

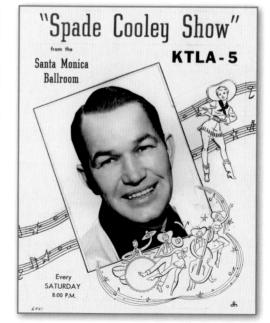

106

Santa Monica Pier

107

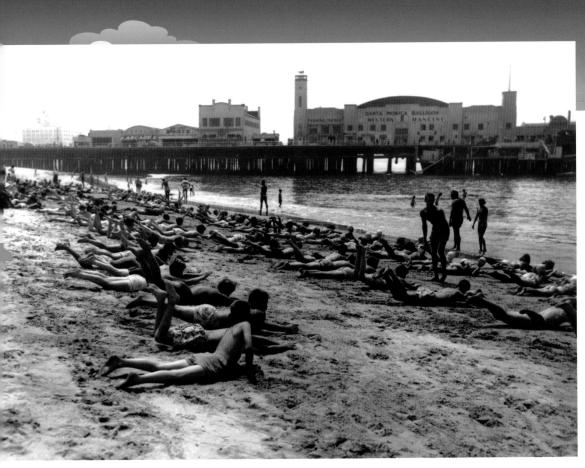

"The Spade Cooley Show" continued with great success in the Santa Monica Ballroom until March 1954, when the show was relocated to the KTLA studios. By 1956, increasing competition and a lack of fresh ideas for the show resulted in sagging ratings. Cooley began to drink heavily and developed a surly attitude. In 1957, he was fired. In 1961 he was convicted of murdering his wife Ella Mae. In November 1969, three months shy of his scheduled release from prison, Cooley was granted a special seventy-two-hour pass to appear at the Oakland Auditorium to benefit the Alameda County Sheriff's Association. After receiving a standing ovation, he stepped backstage and died of a heart attack.

Automobiles once again became the featured attraction of the La Monica when the Hollywood Auto Museum occupied the Ballroom in 1955. Cars on display dated all the way back to an 1898 French-made DeDion Buttoon and included Marlene Dietrich's sixteen-cylinder Cadillac (gas mileage: four miles per gallon), Rudolph Valentino's Lancia and the Auto-Union Horch that Adolph Hitler gave to his lover Eva Braun. Notable celebrities such as Gary Cooper attended opening day of the show.

In 1961, the ballroom opened again as a roller rink, but the aging structure's roof had begun to sag and the walls showed signs of buckling; hopes for new success stemming from the popular roller derbies collapsed along with the building's integrity. In July 1962, the building was roped off and closed to the public. After lengthy evaluation, officials ordered the demolition of the great La Monica Ballroom, leaving behind a vast, empty lot.

A swimming class is taught on the beach while the ballroom advertises Western dancing in the background of this 1950s photo. Right: The ballroom was the perfect venue for the Hollywood Auto Museum's classic car exhibit.

Opposite top: Even in its later years, the ballroom defined the profile of the Pier.

Bottom: Spade Cooley's variety show was broadcast live on local television station KTLA, direct from the ballroom.

SOUNT-NOOM

Past Businesses on the Pier

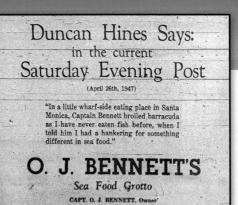

Santa Monica Pier

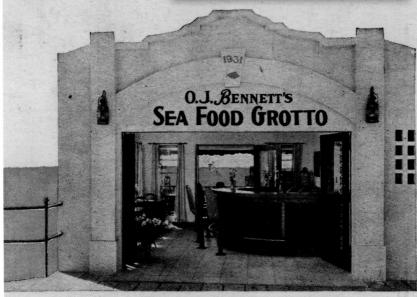

"CALIFORNIA'S MOST UNIQUE"

Specializing in

Sea Food
Cocktails

Clam Chowder

Fish Dinners

Santa Monica

Pier

Free Parking
To Our Patrons

Telephone

Santa Monica

28888

O.J. BENNETT'S SEAFOOD GROTTO

In April of 1931 O.J. Bennett opened his Seafood Grotto on the pier's north side at the Municipal Pier. While it wasn't the first restaurant on the northern section of the pier's first "T", it became the most steadfast. The Grotto's original claim to fame was as an "open air casino" where bridge parties were held over the waves under a colorful canopy. The north-side "T" offered unobstructed, magnificent views of the ocean, the coast, and the Santa Monica Mountains. Bennett's seafood dishes were said to rival those of the great seafood restaurants in San Francisco, Baltimore and New Orleans. Duncan Hines, the famous restaurant reviewer, visited the Grotto and enjoyed Bennett's broiled barracuda so much that he gave the restaurant a substantial review, referring to it in the Saturday Evening Post as "A place I want you to try."

Opposite: Beyond the ballroom and beyond the amusements, patrons in the 1960s, '70s and '80s could walk, bike or skate up to the window of the Cocky Moon and get a quick hot dog.

THE BOATHOUSE

🥡 n 1966, Paul and Sude Blank bought the Seafood Grotto from O.J. Bennett. Paul Blank was a well-known local 🔍 artist who had previously owned an eclectic local bar called the Night Light. He changed the Grotto's name to The Boathouse and refinished the exterior with rustic-looking burnt-wood siding. For financial assistance, the Blanks invited Sude's father Benjamin DeSimone to become their partner. DeSimone, a Boston-bred metallurgic engineer who worked as a consultant for the Atomic Energy Commission, assumed full ownership shortly afterward. Described by the Evening Outlook as a "colorful and gregarious man," DeSimone became well known in Santa Monica for his generosity. He would often purchase lunch or dinner for any uniformed law enforcement personnel he encountered, whether in his restaurant or in any other in which he happened to be dining.

The Boathouse, while known primarily as a seafood-and-steak house, also enjoyed a healthy reputation for its after-dinner live music. While much of the pier struggled to survive after the 1983 storms, The Boathouse secured itself as a primary destination and anchored the pier financially during its toughest stretch. DeSimone passed away in 1989, leaving the property in trust to his grandchildren. His younger daughter Patty, mother to the grandchildren, oversaw operations until her eldest daughter Naia was old enough to take over in 1996. The restaurant was expanded to include outdoor patios on both the pier and the beach level, and its exterior was changed from deep brown to nautical gray. In the late 1990s and early 2000s, Sunday afternoon salsa dancing lessons were offered on the restaurant's beach level patio, becoming one of the most popular destinations in Santa Monica.

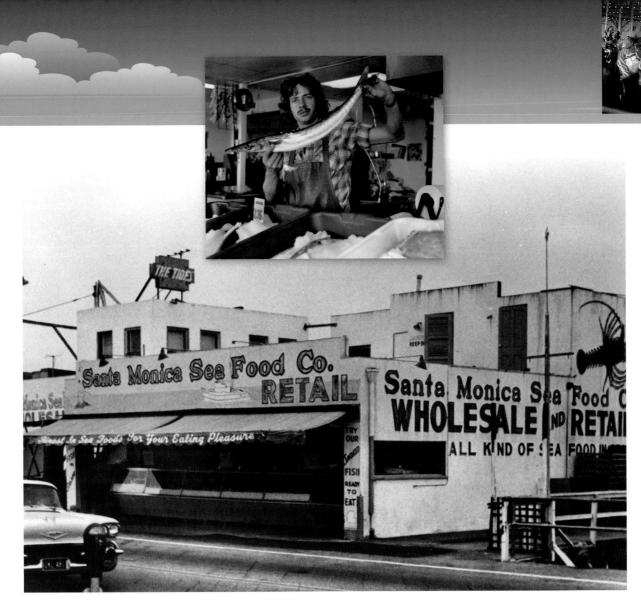

SANTA MONICA SEA FOOD CO.

In 1939, brothers Frank and Jack Deluca founded Santa Monica Sea Food Company, opening their fresh seafood market on the north side of the Municipal Pier selling fresh catches of fish such as halibut, sea bass, mackerel and sardines. The Delucas' timing for opening on the pier was fortunate, for during World War II Santa Monica harbor became a focal point for commercial fishing boats to unload their catches, and Santa Monica Sea Food subsequently became one of the primary distributors of seafood. Thousands of tons of fish, primarily mackerel, were unloaded onto the pier and trucked away by the Delucas, so much so that in 1942 the Municipal Pier deck was considered by engineers to be too stressed by the loads. The Delucas fought to keep business flowing, and even offered to take responsibility should significant damage happen as a result of the heavy loads. Ultimately, they were forced to lighten their loads until the City could repair the deck and substructure so it could handle significant weight. While this put a damper on the Delucas' business during a crucial time of the war, Santa Monica Sea Food survived on the pier throughout the next couple of decades, until it moved inland a few blocks.

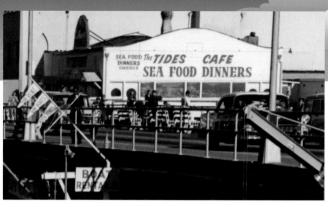

"The Galley" End of Santa Monica Pier	BEVERAGE LIST
60	~
	COCKTAILS
REE PARKING PHONE 28122 Our Own Fishing Sports Bring in Our Fish and Lobstern Dolly	Merchanter 25
WE SPECIALIZE IN	WHISKEYS AND RUMS
FISH DINNERS 60c	Galler Oil 20. Cell Left-grape 5
eamed Clams, Melted Butter, Cup of Clam Broth	LIQUEURS
om Chowder made from Fresh Clams	Cointreux 30c Orange Curatus 25 Hennessy 3*** Copace 35c Chern Frendy 25 Crome de Gocco 25c Apricot Brandy 25 Rock und Rye 25c Crome de Menthe 30
and the second s	SEER AND WINE
rimp Salad 35c Shrimp Cockteil 30c beter Salad 50c Lobster Cockteil 45c o Food Salad 40c Sea Food Cockteil 30c	Terrick Settle

THE GALLEY AND THE TIDES CAFÉ

s Santa Monica Yacht Harbor prepared to open, businessmen carefully eyed the Santa Monica Pier for the obvious opportunities that would accompany it. Ralph Stephan was among those, and in 1934 he opened a small, nautically themed restaurant on the end of the amusement pier, just west of the La Monica Ballroom. He called his restaurant The Galley. Advertised as "A unique South Seas setting" with "twinkling lights and bobbing" and offering "shore dinner deluxe," The Galley was a natural for the pier, catering to the community of seagoing yachtsmen so anticipated by the opening of the new harbor. Stephan proudly boasted on his menu "Our own fishing boats bring in our fish and lobsters daily."

The Galley enjoyed a successful run on the pier until 1946, when Stephan was forced to move his restaurant off of the pier to make room for a yacht club—a club that never opened—and left the building vacant after The Galley's departure. Stephan moved his business to Main Street, where it still operates with the honor of being the oldest restaurant in Santa Monica.

Since the ballyhooed plans for the yacht club fell through, Santa Monica Seafood's Jack Deluca took advantage of the vacancy left by The Galley. After all, it was conveniently located directly opposite the Municipal Pier from his business, and supplying it with fresh-caught seafood would be no problem. He opened it in May 1946 under the not-so-original name The New Galley, later changing the name to The Tides Café. Realizing that restaurant management was not really his forte, Deluca sold The Tides to his manager Joe Guggenmos in the 1950s. Guggenmos continued to operate it, using fish bought from the Delucas, for well over a decade. The café closed in the early 1970s.

Santa Monica Pier

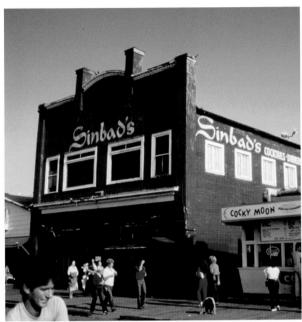

SINBAD'S AND MOBY'S DOCK

esides the Hippodrome and the La Monica Ballroom, the most recognizable building on the pier was perhaps the brilliant red two-story structure known as Sinbad's. Originally built as the Looff Banquet Hall, the building was first located immediately adjacent to the west side of the Bowling & Billiards Building. In the mid-1920s it was moved closer to the La Monica Ballroom, where it housed Hoyt's Chesapeake Café for decades. After Hoyt's closed in 1955, the Newcombs' eldest daughter Bette and her husband Dick Daily moved in, immersed the entire structure with its famous red paint, and opened the pier's first upscale restaurant. A comfortable, spacious restaurant with a fine view of the ocean, Sinbad's offered fare ranging from the standard seafood to rather unorthodox seaside dishes, like beef stroganoff. It was well known for its lively bar atmosphere as well. Jay Fiondella, later famed for his eponymous and legendary Ocean Avenue restaurant "Chez Jay," got his start in the hospitality business as a bartender at Sinbad's. The Dailys eventually separated and divorced, but Bette maintained the family business with her new husband Dick Westbrook until the mid-1970s.

Moving their operation into the vacant building that was formerly The Tides Café, the Westbrooks redecorated and opened a new restaurant named Moby's Dock. They decorated the restaurant with red-checked tablecloths and an appropriately nautical theme. The exterior of the building was decorated with paintings of cartoon-like whales and a large white whale tail sculpture that appeared as though the great Moby Dick himself had crashed into the restaurant looking for a bite to eat. In 1977 the Westbrooks sold the restaurant to Clarence Harmon. Harmon kept the name and Moby's Dock thrived until the storms of 1983 caused such damage to the restaurant both structurally and business-wise that Harmon was unable to keep up with rent payments. In 1984 Harmon was evicted and Moby's Dock closed its doors for good.

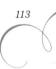

Pier Icons

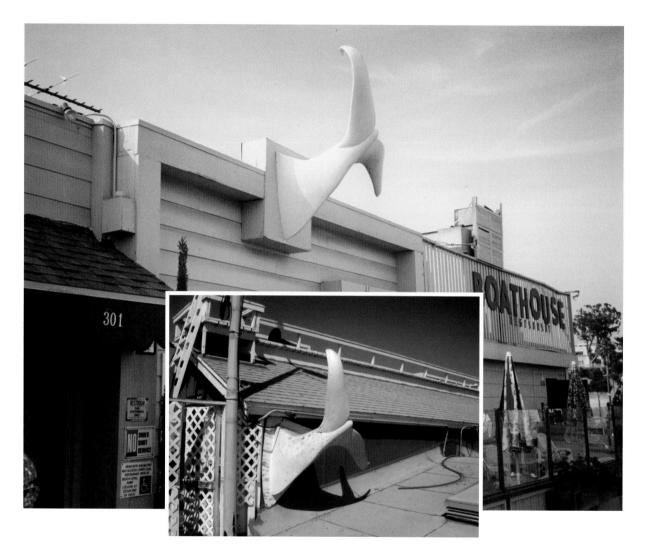

THE WHALE'S TAIL

hile the Moby's Dock structure has long since vanished from the pier, its trademark white whale's tail has managed to surface in various locales around the pier. After the demolition of Moby's, Ben DeSimone acquired the sculpture and had it placed prominently at the front of The Boathouse. From there, the tail waved to millions of passersby until this second home found a fate similar to its first. As The Boathouse was being razed, the Pier Maintenance crew rescued the tail and gave it a new home above their workshop. A true survivor, this resilient piece of décor has developed something of a kinship with the pier.

114

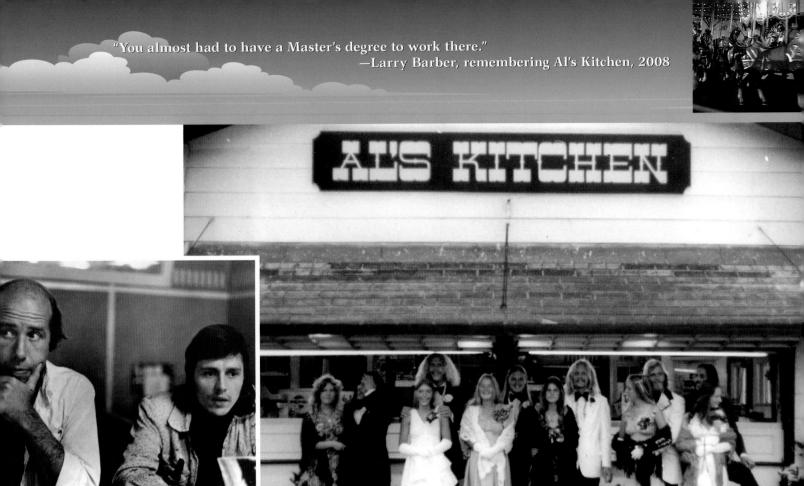

AL'S KITCHEN

I's Kitchen, a small indoor/outdoor café, was known perhaps less for its food than for its patrons and the people who worked there. The restaurant, originally owned and named after Al Bond, saw its brightest days under the waitress to whom he bequeathed it when he retired—an Englishwoman named Joan Crowne. It became a haven for local activists and artists, including Jane Fonda and politician Tom Hayden. Kitchen and waitstaff over the years included Julie Stone, one of today's more successful restaurateurs; Claude Bessy (inset, right), the founder of the punk rock magazine Slash; Pat Lennon of the popular rock band Venice; celebrated Los Angeles poet FrancEyE; and Larry Barber, associate minister of the Founder's Church. Managing a crew of this magnitude and talent took a special person, and Joan Crowne found that in Jack Sikking (inset, left), former manager of Hollywood's Troubador night club. Legend has it that Sikking, fed up with Hollywood, walked out of his job one day and headed for the beach. He found himself walking along the deck of the pier when all of a sudden he felt as if he were home. Contemplating his life over a cup of coffee at the counter of Al's, he inquired about a job. Something of a visionary, his interest extended far beyond the limitations of a small café. Within a short time he had his hand in everything involved with the pier and is generally credited today as being the mastermind behind saving the pier from demolition in 1973.

115

Pier Icons

Santa Monica Pier

The Pier's Memory Lane

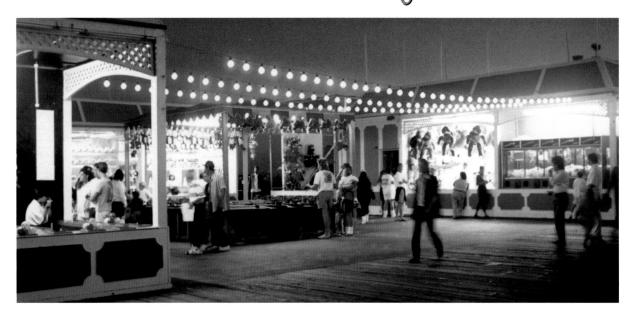

ome places are just plain unforgettable, not for any particular reason other than they defined a place in time. To the people who saved the pier in 1973, the row of shops and cafés between the Hippodrome and Moby's Dock did just that. They defined their beloved pier.

Occupying the old Bowling & Billiards Building was a series of such distinct businesses. Beryl's Art Novelties Studio occupied the east side, displaying in its front windows a variety of ceramic lamp bases, figurines and masks. Next to it was the Fish 'n' Chips café, well known for its homemade potato chips, whose aroma wafted across the entire pier and became so famous that modern-day restaurant legend Bob Morris purchased the restaurant in 1978 just to be a part of what had become a great pier tradition. Seaview Seafood, an open-air fresh-fish market traditional to piers and wharfs everywhere, was just beyond it. Selling fish and shellfish caught from the boats that regularly

For years the pier's midway games were located along the midsection of the pier's main walkway, a place to stop by, toss a ring to win a prize before continuing to the end of the pier.

Opposite: Clockwise from top left: Fish 'n' Chips was best known for their homemade potato chips; Doreena told fortunes on the pier for more than half a century; Beryl's was a much-loved ceramics shop; customers used actual .22 caliber rifles at the Shooting Gallery; Playland Arcade has been owned and operated by three generations of the Gordon family; formerly located on the west end, Oatman Rock Shop relocated to the central part of the pier after the 1983 storms.

116

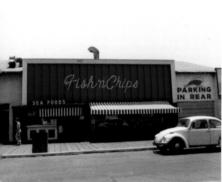

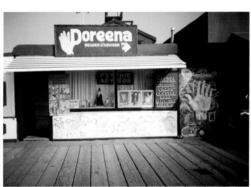

serviced the pier, the Seaview was a destination spot for anyone with an appetite for good, fresh seafood.

Clara's, a fast food café, fed hungry visitors with hot dogs and ice cream, and next to it was a haven for souvenir shoppers—the Beachcomber gift shop. An assortment of booths stood a bit further west, housing carnival games such as the milk can toss and basketball shoot. Surrounded by the chaos of these games, somewhat like the eye of a hurricane, was the spiritual office of Doreena, the pier's longtime fortune teller. Operated by the Dewey Adams family, Doreena's moved onto the pier in 1943 when the City of Santa Monica passed an ordinance that stated that the only place in which fortune-telling was permitted was on the area's amusement piers. As popular with those who sought serious spiritual guidance as with those who just wanted to have a little fun, fortunes told by generations of Adamses were long a vital part of the pier's fabric.

Playland Arcade holds the distinction of being the longest family-run business ever operated on the pier. Owned by the George Gordon family since 1954, the "last arcade in Santa Monica" is now managed by the fourth generation of the family.

The title of second-longest owner is held by Christine Volaski, whose Oatman Rock Shop has weathered all varieties of storms since 1965. Originally located at the west end, the original shop lost everything to the storms of 1983. Shortly after the waters settled, the store found safer quarters over the inland section of the pier.

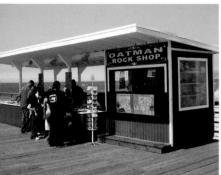

Rides & Amusements

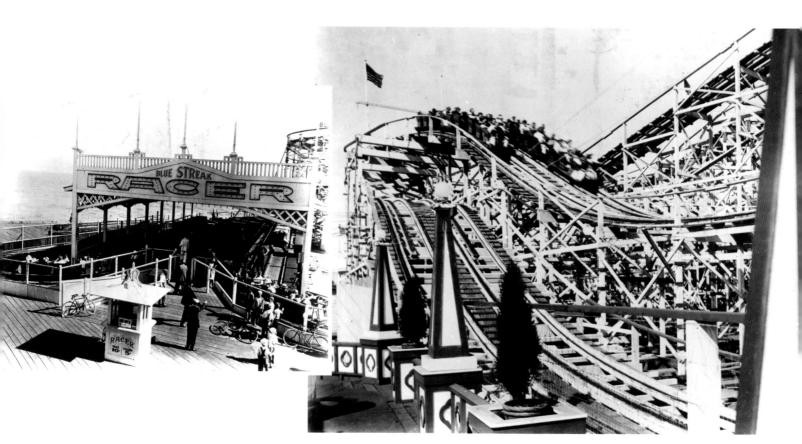

BLUE STREAK RACER

he Blue Streak Racer was a racing-style coaster; it had two tracks running side-by-side with cars on each track running simultaneously, literally racing through the coaster's six loops and twenty-four dips. The Blue Streak reached an apex of sixty-five feet and ran its cars across a mile of track. Upon its opening it was described as one of the most thrilling rides on the Santa Monica Bay.

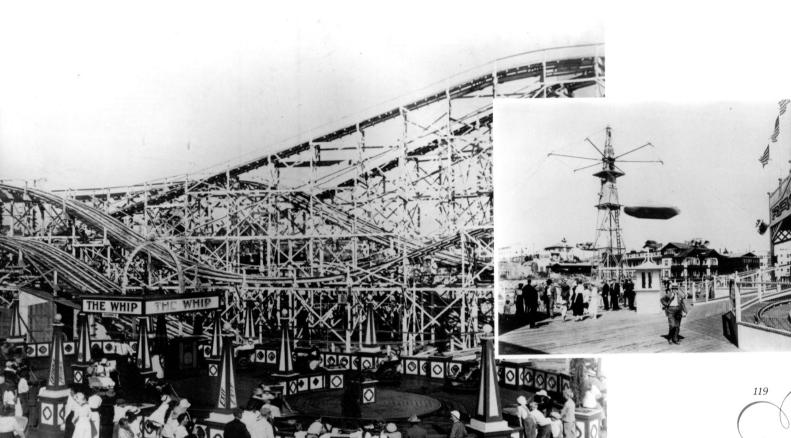

THE WHIP AND THE AEROSCOPE

hen riding The Whip, two passengers would ride side-by-side in a small car around a course shaped like a racetrack. At each end of the track were turns that cars would take at such great speed that riders were forced together as they whipped around each curve. Passengers road the giant Aeroscope in "flying boats" that swung at angles of nearly forty-five degrees, circling the central core at speeds up to forty-five miles an hour. Riders could not lift their bodies from the seats no matter how hard they tried, the physics of the swing keeping them secure in their boats.

Pier I

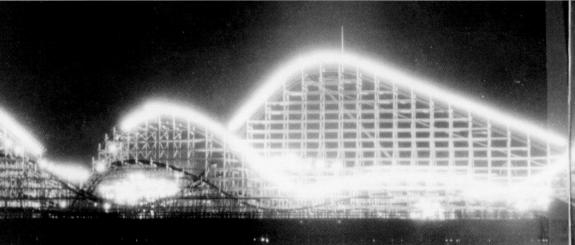

THE WHIRLWIND DIPPER

former pilot from Canada, C.B. McConnely, commented that his experience riding the Whirlwind Dipper was comparable to that of flying in a stunt plane, giving him chills up and down his spine. That summed it up for adults, but it took a child to really capture the coaster's allure.

The Evening Outlook newspaper billed the Whirlwind Dipper as "The Greatest Ride Ever Built," but wanted to get an honest opinion from those who would be its most loyal riders—children. So the Outlook held an essay contest through the newspaper. The child who wrote the best letter describing the towering, twisting new coaster would receive a season pass. Young Ben McFee of Santa Monica won with the following letter:

"Hold tight all the way and don't stand up," shouted the man and then we were off. Before I could count ten we had passed through the spooky tunnel and were on our way to the top of the big dip. That was the minute that seemed like a year. I got cold and then hot, and I turned all colors of the rainbow before I reached the top of the big dip. Oh boy, here we go Yeh-h-h-h Boo-o-o! Gee what a dip, and here we come to another one, and another one, and another one and, gee-whiz, how many more are there? I've lost my breath. I wish they would stop this thing for a minute. Good night, aren't we nearly through yet? That last dip almost threw me out, and here we go down another one. Oh my! What a funny sensation that was. This thing goes too fast to suit me, and all I hope is that I reach the bottom alive. "Have your fares ready, please." What sound could be sweeter? For at last we have reached the bottom, and I am still alive, thank goodness. Just the same, the ride was great and the best ever. I surely did as the man commanded me, for I never held on so tight in all my life. As for "don't stand up," well it was all I could do to stay in my seat. Of all the excitement, speed and thrills, well all I have to say is that the Whirlwind Dipper is by far the best ride yet. Fellows, if you want to get the kick of your life, just try the new Whirlwind Dipper once, for it sure is some wicked ride.

With an endorsement like that, the *Evening Outlook* offered free rides on the coaster to all children who clipped out the ad and presented it for admission. What parent could say "no" to buying the paper?

Santa Monica Pier

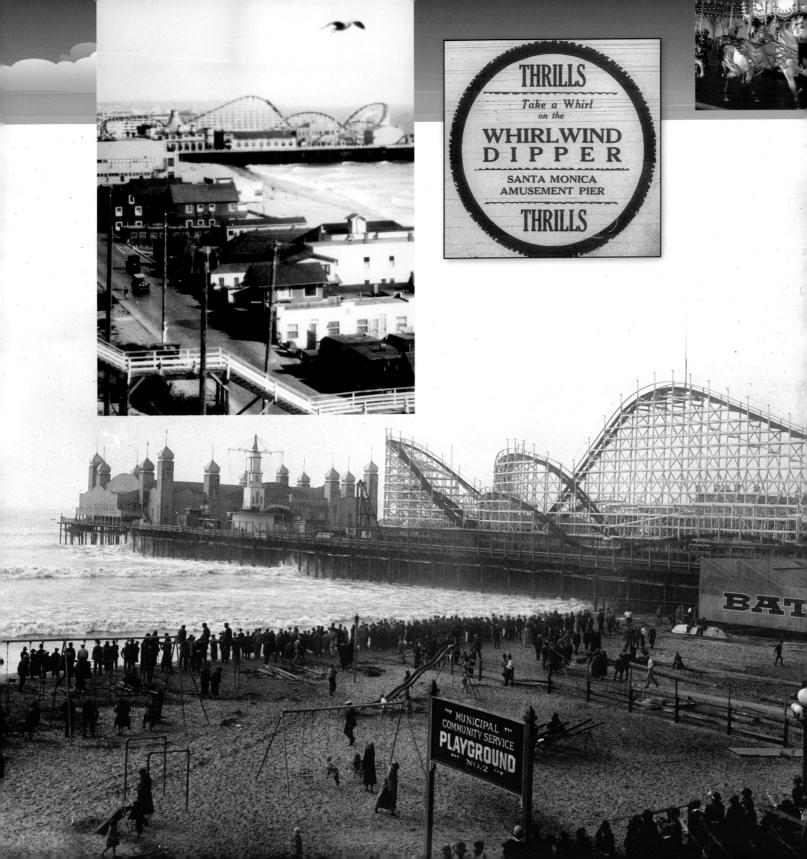

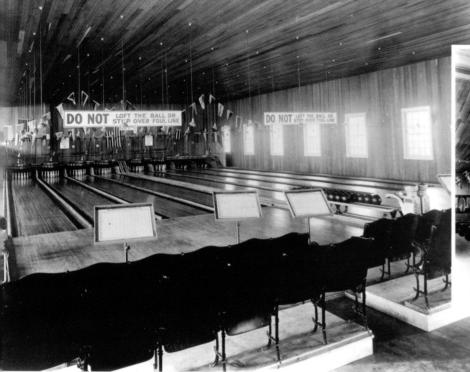

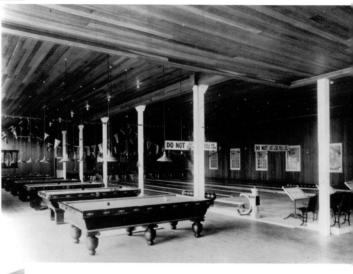

BOWLING & BILLIARDS

In 1917 Charles Looff completed the second structure on his pier, the Bowling & Billiards Building—home to Santa Monica Bowling Alleys. The venue featured eight bowling lanes, one Brunswick billiard table and seven Brunswick pocket-billiards tables. Looff's goal was to maintain the most up-to-date amenities available, so he went to great efforts to obtain and install automatic pin-setting devices, a rarity at the time.

Santa Monica Bowling Alleys opened to the public on Wednesday, January 16, 1917. Mayor Samuel Berkley rolled the first ball, and then struck up a highly touted match against Police Chief Ferguson. The mayor should have stopped with the honor of rolling the first ball, for Ferguson out-bowled Berkley two games out of three. The police chief's prize for winning Santa Monica Bowling Alleys' first match was a silver-plated bowling pin. The consolation prize awarded the mayor was a bottle of ketchup. The night's activities proceeded with another highly anticipated match—the Los Angeles All-Stars versus the Santa Monica Home Guards. The Home Guards championed Santa Monica by winning two out of three games. Former local baseball star "Dad" Meek rolled the night's high score, an eyebrow-raising 225.

The bowling alley continued drawing crowds to league tournaments for several years. In the spring of 1924 Martin "Pop" Kern, three-time United States bowling champion, assumed management of the alleys, renaming the establishment Kern's Alleys. Pop, a national icon in the sport, proved to be an excellent manager and teacher who remained on the pier until his death in 1926. By the early 1930s, the pier's bowling alleys were just a memory.

122

BUMPER CARS

In 1972 amusement entrepreneurs Maynard and Sheila Ostrow opened the bumper car ride near the amusement pier's west end. The electric cars, powered by an overhead grid, quickly became a favorite attraction on the pier. Perhaps even more notable than the ride was the classic, "antique" ticket booth. In truth, however, the old booth was even newer than the bumper cars themselves. The Ostrows commissioned employees of Al's Kitchen to build the booth. Jack Sikking, manager of Al's and a close friend of the Ostrows, suggested that the newly built ticket booth be distressed for a vintage, "worn" look. He assumed the job of finishing it himself, and the results were so convincing that tourists and even museum curators began to inquire about the value of the "old antique."

124

The Twilight Dance Series

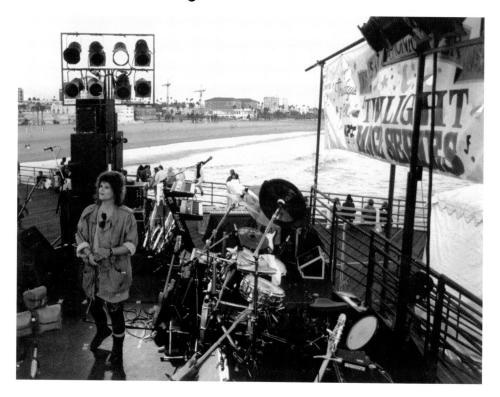

he success of 1983's Save the Pier Week caused an eye-popping realization: the Santa Monica Pier is a great concert venue. Katharine King, the woman responsible for the entertainment during Save the Pier Week, recognized the potential immediately. Not since the glory days of the La Monica Ballroom had the pier hosted regular concerts, and King decided to regenerate the excitement of those days with current, unique entertainers. The next year, King assembled another free concert series, this one running for four weeks in the middle of summer. The City took notice of the series' popularity, and in 1985 the Santa Monica Arts Commission budgeted seven thousand dollars for King to produce a free event that would allow dancing on the pier. What she created was a concert/dance series that ran for seven weeks throughout the summer.

King determined that the shows should be scheduled during its most magnificent time of day—sunset. She considered Thursday nights to be ideal because they were "almost the weekend," increasing the likelihood that the public would come to enjoy a weeknight out with only one more work day ahead. Upon assembling it all, she named the series the "First Annual Santa Monica Twilight Dance Series." A summertime tradition was born.

For the first four years King managed to provide exceptional shows on a minimal budget. An established producer/promoter before the inception of the series, King was able to rely on professional friendships, bringing in quality acts such as Poncho Sanchez and the Rhythm Kings, acts a limited budget wouldn't otherwise afford. In 1989, corporate sponsorships helped fund the series, enabling King to afford acts such as Bo Diddley and Los Lobos. The series quickly developed a reputation for mixing lesser-known in-

ternational acts with classics in the musical world. Such an eclectic mix helped the series grow into the premier event

in Santa Monica as well as one of the longest-lasting free concert series in Southern California.

The Twilight Dance Series became so popular and so integral to the success of the pier that it spurred other cultural series. Since 1991, the Santa Monica Pier Lessees Association has produced an annual series of Sunday afternoon concerts each spring. In 2003 the Pier Restoration Corporation formed two partnerships, one with Arts Fighting Cancer to produce an annual outdoor movie series called

the "Santa Monica Drive-in at the Pier" and the other with the Santa Monica-Malibu Education Foundation to host an annual "Celebration for the Arts." In 2006, a new Saturday morning concert series called "Wake Up with the Waves," was introduced to provide young children with their own music event at the pier.

FREE!

Each year's artwork is greatly anticipated, with t-shirts becoming collector's items, particularly this glow-in-the-dark one from 2007.

Pier Icons

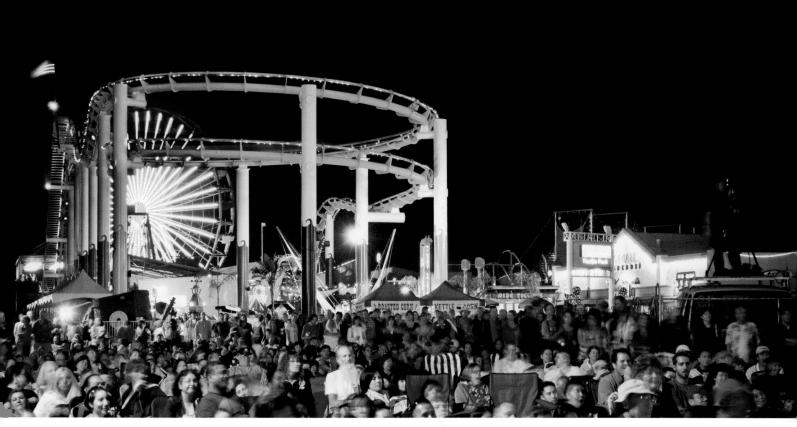

Top and opposite top: The Twilight Dance Series draws thousands of people to each of its shows, making it among the Los Angeles area's most popular annual summer events.

Left and opposite: Posters used to advertise the Twilight Dance Series have been as artistically diverse as the musical lineup.

Since 2003, an annual public design contest has been held with more than one hundred entries each year.

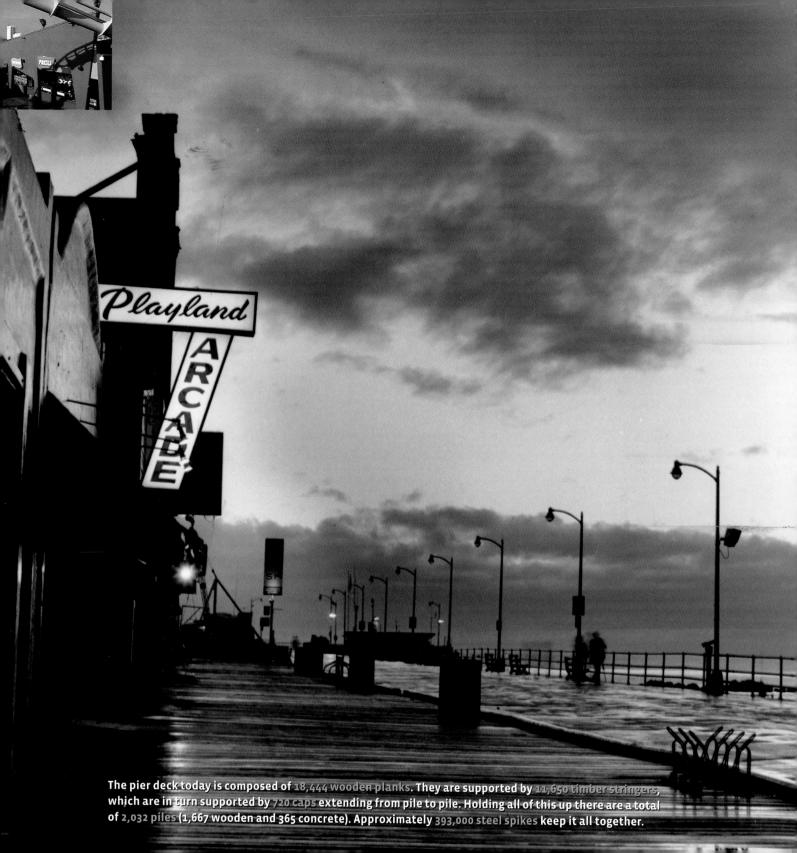